CROSS COUNTRY

A 3,700-MILE RUN

TO EXPLORE

UNSEEN AMERICA

CROSS COUNTRY

A 3,700-MILE RUN

TO EXPLORE

UNSEEN AMERICA

RICKEY GATES

CHRONICLE BOOKS

SAN FRANCISCO

Library of Congress Cataloging-in-Publication
Data available.

ISBN 978-1-4521-8088-5

Manufactured in China.

Design by Jon H. Glick.

10 9 8 7 6 5 4 3 2

Chronicle books and gifts are available at
special quantity discounts to corporations,
professional associations, literacy programs,
and other organizations. For details and
discount information, please contact our
corporate/premiums department at
corporatesales@chroniclebooks.com or at
1-800-759-0190.

Chronicle Books LLC
680 Second Street
San Francisco, CA 94107

www.chroniclebooks.com

To Liz—for giving me something to run toward.

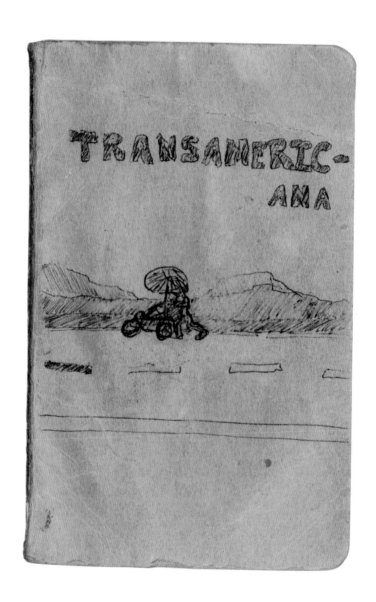

A note on the chapter titles: Though The Appalachians, The River, and The Ozarks all technically exist in the South, the author has given them their own chapters due to their distinct terrains and cultures.

Names of some of the subjects have been changed per their request.

CONTENTS

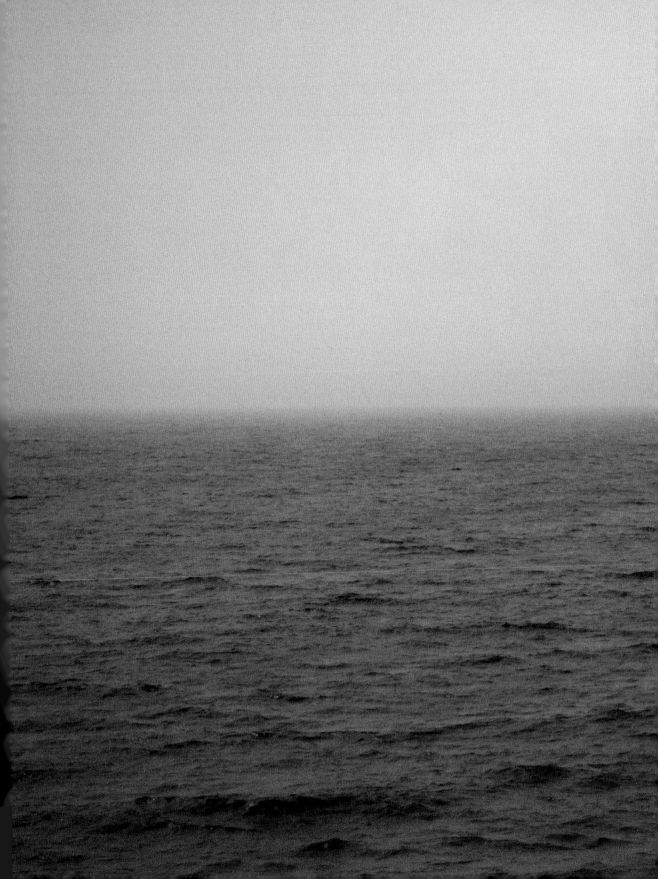

THE BEGINNING

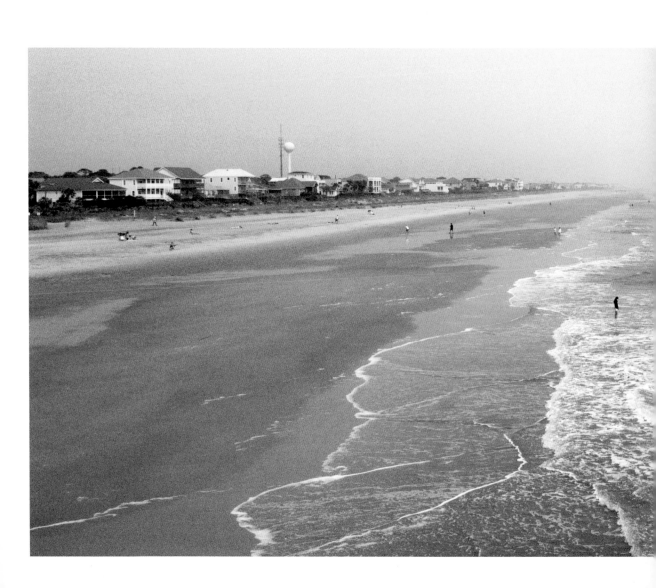

This story starts off on a beach, sad and lonely.
I think that this is how I wanted it to start. Or this is just how it has to start. My wishes no longer have any bearing on this precise moment. I have only my actions and their consequences to thank or to blame now.

I barely set foot in the water—enough to wet the sole of my shoe, but not enough to actually get my feet wet. I hate the beach. I hate wet shoes. And more than both of those, I hate wet beach sand in my shoes. But, if I'm going to run across the country, from sea to shining sea, as I've so boldly proclaimed, this is where it must begin—my shoes sinking into the sand at Folly Beach, South Carolina, where the town's welcome sign informed me that this is The Edge of America. Folly.

I stood there, sinking slowly into the sand with the far-reaching Atlantic Ocean spread out before me. Behind me is America. All of it. Unsure if that sprawling mass of people and earth was pushing me away or pulling me in, I did what I thought I was supposed to do and reviewed the life events and thought processes that brought me here.

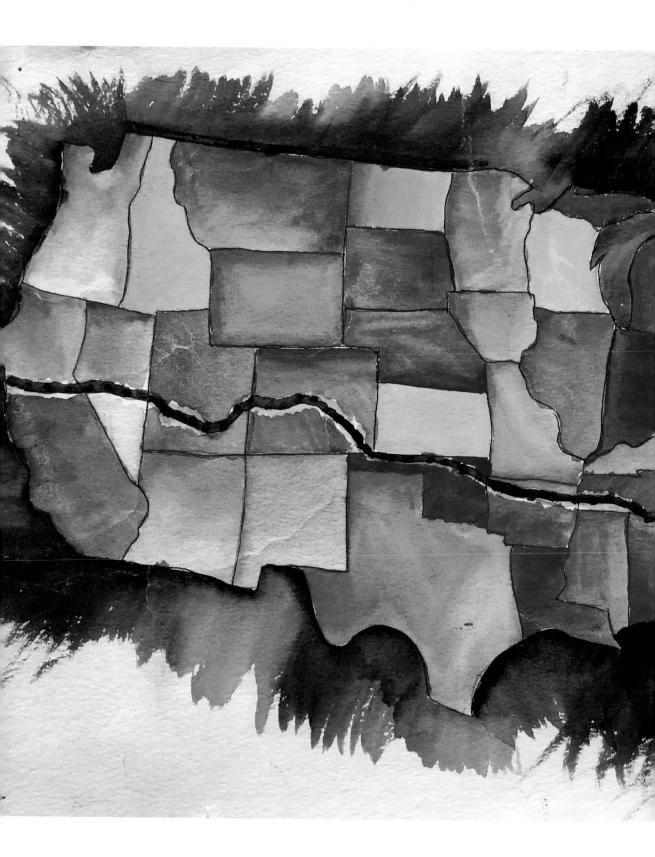

FIVE MONTHS EARLIER I woke up with a hangover and Donald Trump as our newly elected president. Both were painful and real. Only twelve hours earlier, Liz and I were prematurely and erroneously celebrating the first female president's historic win at Plan B—a gay bar in downtown Madison, Wisconsin, where Liz was in her final year of a three-year MFA program and I was figuring out ways to continue avoiding ever getting a real job. With balloons and streamers and clownish Trump piñatas to be busted open when victory was announced, it was meant to be one of the better election night parties in a town that prides itself for its progressive politics. But as the night dragged on, one state after another informed us not only that Hillary Clinton was not going to be the first female president but that we really didn't know the country that surrounded us. Shock, anger, sadness, and confusion began to reign, and Liz and I found ourselves to be the only two people dancing. It was all we could do as the piñatas remained intact. We went home as Wisconsin was being called for Trump.

I was managing my depression rather poorly. I neither bothered to conceal it nor did I make any effort to get to the bottom of my sadness. Maybe Madison was to blame, and Liz and her graduate school ambitions that had kept me here. Maybe it was the idea that my country and neighbors voted for something so obviously wretched and disgusting. Deep down though, I knew that Madison, Liz, Clinton, and Trump would not have solved any of my problems. I would have still only seen what Wisconsin wasn't rather than what it was. I would have still resented Liz for dragging us here. I would have still been thirty-six years old, aging out of a niche sport, where I was barely making enough money to pay my half of the rent.

I shuffled from the bedroom into the living room where, just beyond the front windows, the morning traffic was well underway, rattling the thin, old glass. I stood before a display case mounted on the opposite wall containing evidence of my life's ambitions over the past fifteen years. Two hundred and eight little jam jars of dirt and sand lined the shelves, each meticulously labeled with the place where I had collected them. The lot of them spanned seven continents and over thirty countries.

MALLORCA, MADEIRA, MCMURDO Repetition has long been at the center of my own personal awareness. To collect and catalog the earth that I've encountered from my travels around the world is to give it life beyond the brief moment I tread upon it.

LAGO GREY, PLAYA ESCONDIDA, MONT VENTOUX From the initial moment of realizing a new location to selecting the dirt to transporting it across land and ocean to the labeling and displaying of the collection, the project created its own form of meditative nostalgia for a place and the person I was at that moment.

THE RIVER THAMES, THE AMAZON, THE NILE As both record and shrine to a former life of wanderlust and curiosity, my collection of dirt sat before me, reminding me of all the places where I would have rather been. Absent from the shelf was the one place where I actually was. Whatever. It was outside.

SKAALA, SORRENTO, SAN SEBASTIAN My hangover and I continued on to my desk where a stack of race numbers sat, awaiting inspiration. Dating back over twenty years, the bibs invoked a life of races on all seven continents. As with my collection of dirt, they served as a reminder of the person I was during certain moments in my life—the skinny high school kid trying to break eighteen minutes in the 5K, the waiter trying to make the US Mountain Running Team, the dishwasher at the South Pole competing in the 2.2-mile Race Around the World, or a barely sponsored athlete trying desperately to remain relevant.

8/19/12: GRINTOVEC, SLOVENIA 12 kilometers (2,000 meters of climbing). 1st. 1:12:47.
8/7/13: CANADIAN DEATH RACE, ALBERTA 125 kilometers. 1st. 12:07:40. Course record.
9/12/11: WORLD MOUNTAIN RUNNING CHAMPIONSHIPS, SIERRE, SWITZERLAND 12 kilometers. 11th place. 47:19.

From alongside the pile of bibs, I pulled a small notebook closer and opened it. For the past month, every day since I announced that I would be running across the country, I committed myself to one drawing per day—specifically, a map of the contiguous United States done from memory. The repetition and routine forced me to reckon with my lack of understanding and knowledge of the country I call home. The number of states varied from less than forty to over sixty. The Four Corners sometimes only contained three; Cape Cod, the Chesapeake Bay, and Puget Sound were routinely eliminated. Florida was all sorts of different dangles. Missouri and Indiana frequently disappeared. In one map, Texas dominated over half the country.

Following a night filled with television images of red and blue electoral maps, I was confident that I would put together one of my more accurate maps, but also fairly certain that knowing the shape of the country meant little in terms of actually understanding the country. I flipped to the next blank page and set the point of my pen down on the top left corner. It traveled down the

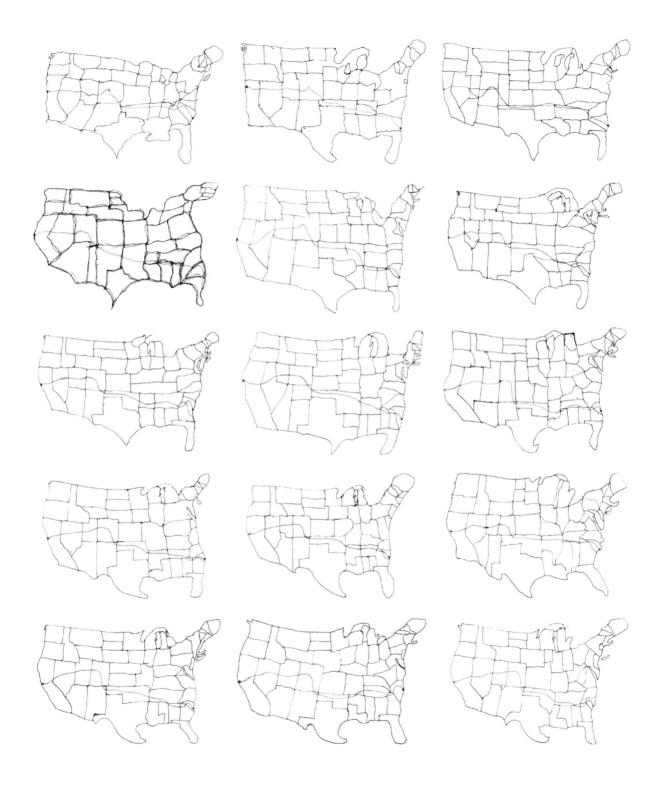

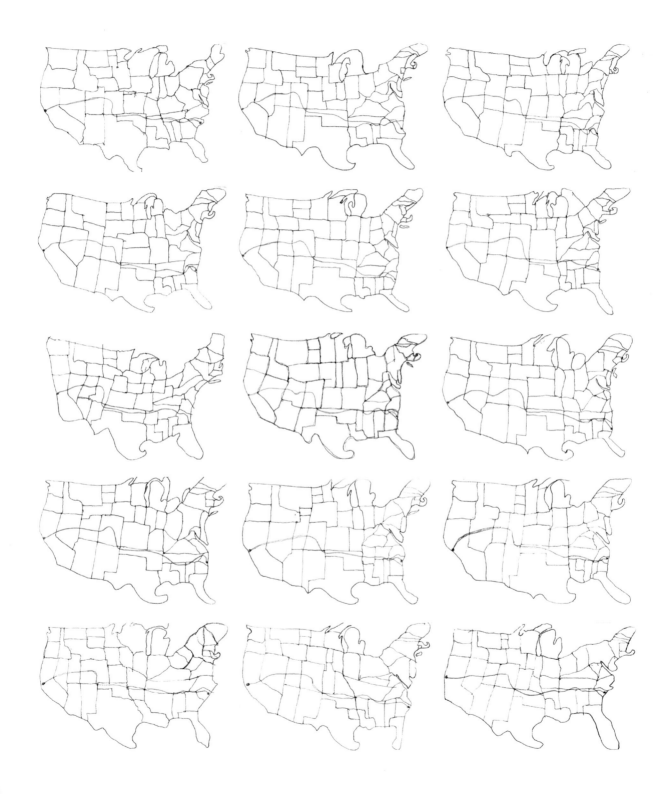

Washington and Oregon coast, bulging out along the central coast of California and down to the border of Mexico. Across and down for Arizona, New Mexico, and then following the Rio Grande along the southern border of Texas to the Gulf of Mexico, carving out the southern outline of Louisiana, Mississippi, Alabama, and the Florida dangle before curving up and out for the rest of the South. My pen squiggled the outlines of bays, islands, and capes up to the dull horn of Maine before making its way back down and to the left to form the Great Lakes, Michigan's glove, the Upper Peninsula, and the Boundary Waters. From there, it's a straight line along the forty-ninth parallel all the way back to the northwest corner of Washington. After filling in the country's outline, I inserted the Mississippi River, then all the square states, then the northern borders, or Texas and Florida. The rest of the South followed, and then New England, and then the Midwest, and finally the Rust Belt. It wasn't perfect, but it was the most accurate map I'd drawn up until that point.

The final touch was to add the route for my run.

Given my self-inflicted misery in Wisconsin, I couldn't help but throw myself into the planning of my route. Though I had never attempted a distance of this magnitude, I had learned over decades of running and racing that to cross a place on foot is to observe and participate in a vast and complex web of infrastructure. It is to experience the history of that place in a very real and personal way. It is to have a better understanding of what that place is.

From the beginning, I wanted my route to inform me of who we are as Americans. Why we are the way we are. And where we came from. Study that enough, I figured, and maybe we'll be able to determine where we are headed. I had given my route a great deal of thought in the months and years since the trip's inception and knew that it had to contain certain elements in order to keep myself entertained. I knew that it would have to incorporate American history, natural history, and my own personal history. I wanted my route to be immersed in nature, be that trails, mountains, desert, or river, but to return to civilization often enough to remind me why I was doing this.

Once I established these parameters, my route began to take form through a connect-the-dots of emerging interests. Like the growth and expansion of the United States, my route would begin in the East and finish in the West. From Lewis and Clark to the Pony Express Trail, from the Mormon Trail to the Trail of Tears—over the past several centuries, this migration has helped solidify who we are as a people.

Having very little personal experience in the South, and having felt like it is the most misunderstood region of the country, I thought it would be a good place to start.

Edward Abbey said, "Mountains complement desert as desert complements city, as wilderness completes civilization." To maintain the balance of roads and city, I would need wilderness. Lots of it. I scoured maps in search of natural trails and was grateful to find hundreds of miles of trail to help carry me across the South, through the Appalachians, the Ozarks, and the Rockies, the American Desert, the Sierras, and along the Pacific coast.

I knew that my route would need to go down a river in some way or another. Throughout the course of human history, when a physical advantage could be taken, it would. The command of the boat and water, even going upriver during an age that was void of motors, was considered advantageous.

I knew that I wanted to visit my home in Colorado, and I knew that I wanted to finish in San Francisco, the city Liz and I called home prior to our move to Wisconsin. However lonely Folly Beach would be, I knew that I would want people at Ocean Beach on the opposite side.

I traced a red line across my newly sketched map—a thin thread that, to me, represented history, success, oppression, expansion, wilderness, efficiency, fatigue, perseverance, and so much more. On November 9th, 2016, as I drew a line across a nation that had been divided in two by politics, media, and fear, I knew that my run was going to be more than just a journey of self-discovery.

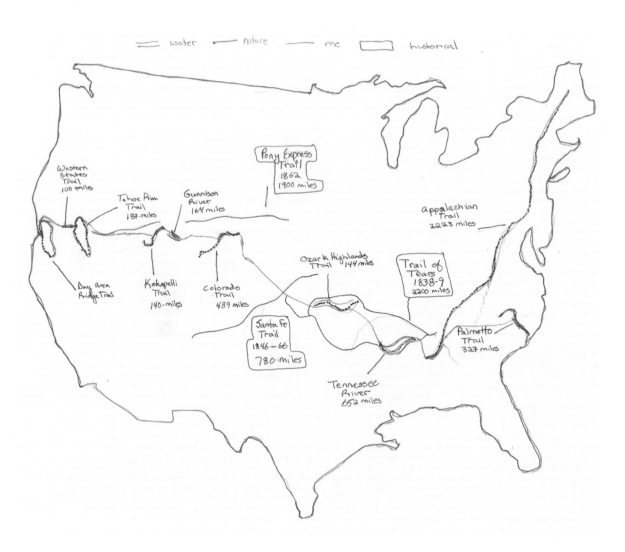

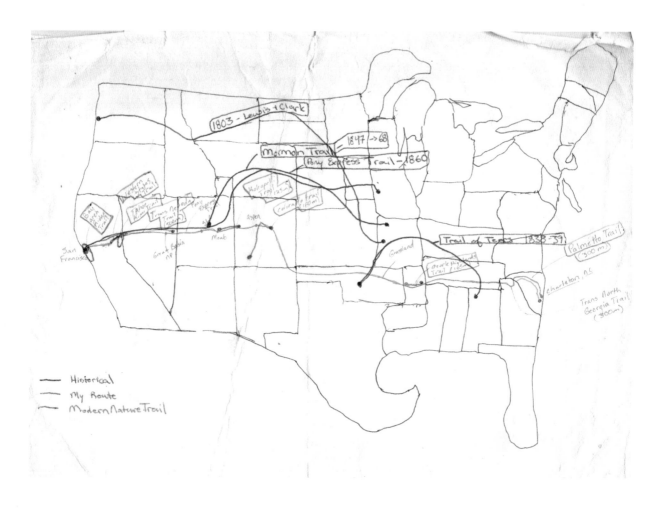

Legend:
— Historical
— My Route
— Modern Nature Trail

Map labels: 1803 - Lewis + Clark; Mormon Trail - 1847 → 68; Pony Express Trail - 1860; San Francisco; Great Basin NP; Moab; Aspen; Graceland; Trail of Tears 1838-39; Palmetto Trail (300 m); Charleston, NC; Trans North Georgia Trail (300m); Ozark Highland Trail /160

FOUR MONTHS EARLIER I drove away from Madison in a bitter rainstorm. My confusion and sadness reigned. Liz and I had broken up. I had no idea what I had just done other than to have followed through with an intense desire to sabotage our relationship.

I had a website that said I was going to run across the country. It said that I was doing it to get to know my country a little better. That I knew more of Germany than I did of the South. That I knew the elevation of the Antarctic plateau but I didn't know where the Ozarks were.

But really, I was thirty-six years old and on Medicaid. I was a professional runner who smoked too much pot and hadn't had a notable finish in a big race in years. My relationship to my title sponsor was largely based on being weird and staying in close contact with the filmmakers who had filmed various exploits of mine over the years and would continue to do so with this one. I pivoted my sad excuse for a career, my relationship, and my health and well-being on crossing the country on foot to get to know my own country at the speed of one step at a time.

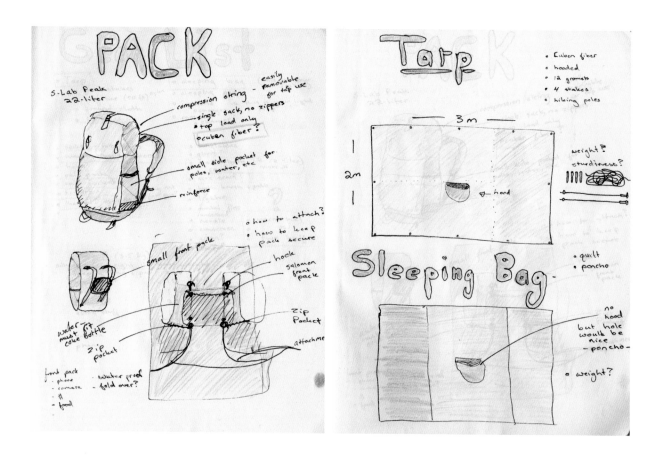

PACK

S-Lab Peak
22-liter

easily removable for tarp use

compression string -

single sack, no zippers
top load only
ocuben fiber?

small side pocket for poles, water, etc

reinforce

small front pack

how to attach?
how to keep pack secure

hook salomon front pack

zip Pocket

attachme

water bottle
must fit coke bottle

zip pocket

front pack
- phone
- camera
- $
- food

- water proof
- fold over?

Tarp

- Kuben fiber
- hooded
- 12 gromets
- 4 stakes
- hiking poles

3 m

2m

hood

weight?
sturdiness?

Sleeping Bag

- quilt
- poncho

no hood but hole would be nice -poncho-

weight?

THREE MONTHS EARLIER I flew to France to meet with Salomon. I explained that I didn't need any money, which is the single greatest sentence a sponsor can hear from an athlete. I explained that I was going to run across the country with my own money, on a slim budget of one thousand dollars a month for five months—a poverty-level existence that would accommodate for roadside food, an occasional motel room, and a gas station beer or two at the end of the day. Though I'm no stranger to cheap, roadside food, I had never subsisted entirely off it for as long as I was intending to. I explained to them that I wanted my trip to be something that a "normal" person (whoever that might be) could do, and to have financial or logistical support would nullify that goal. I showed them my gear list and the rudimentary sketches of a few items that would allow me to stick to a pack weighing under twelve pounds. And then they got to work.

TWO MONTHS EARLIER I had been staying with my mom in Colorado while Liz and I remained broken up. We drank beer and whisky while she went on passionate rants about Trump and all his evils and how she'd never seen anything like this before. I didn't really care because it wasn't about Liz. She tried to get Liz and I back together, because she knew that I was lucky to have her. Very lucky. I told her flat out I had no idea what I was doing. In life. In this weird pursuit. I had no idea what I was hoping to discover. I had no idea why I was doing it. All I knew was that it was in motion and now it needed to be done.

To solve the problems of love and lust and hate and sadness that I'd caused, I enrolled in a ten-day silent meditation retreat. I had done this retreat in the past. It had helped with empathy and understanding myself and I thought that it might help with this. But this time it was pure torture. Worst of all, I lost several precious pounds of weight as a result of intermittent fasting and stress. I walked away sadder and more confused than when I'd gone in, but knowing that perhaps self-love was in short supply.

I drove one thousand miles east to Wisconsin to beg forgiveness. I felt crazy—completely insane. Listening to relationship podcasts and reading relationship books and all of this just came down to deeper fears—of what, I wasn't sure. Though Liz was happy to see me, we both agreed that it would be best to stay broken up. I drove back to my mom's house in Colorado.

THREE WEEKS EARLIER My gear arrived from France. My brother volunteered to hold on to a box of stuff that he would send out to various post offices across the country. The box contained a half-dozen shoes, Cheeba Chews, extra layers of clothes, and things that might need to be replaced.

I started putting weight back on after Liz agreed to start speaking to me again. Once a week. She said she was still hurt and I told her, "I know." I didn't say that there will be a part of her that will be mad at me forever. It's like a scar. On her face. That I made. It will always be there. I will always look at it. She will see it only sometimes.

SIX DAYS EARLIER I rallied my sister's 1994 Toyota Corolla past semitrucks and snowplows to reach Madison, which is not necessarily between Colorado and South Carolina, but Liz had agreed to see me before I set off. As I outsprinted the storm, I thought what a shame that I need to sell this car in Charleston. It's got another 100K in her for sure. Posted for $1,100 on Charleston's Craigslist, I hoped that somebody would recognize a good deal for a quick sell.

When I arrived in Madison, we made love and drew comics and kinda laughed about how much I'd fucked everything up but also admitted that it would likely have happened eventually. We agreed to stay broken up.

I left the next day.

ONE DAY EARLIER I got an Airbnb in the outskirts of downtown Charleston. Jared, a soft-spoken videographer from South Africa, was filming my setup. This is what I packed:

A twenty-liter, waistless pack, sleeping bag, sleeping pad, silk sleeping liner, tarp/poncho, Tyvek ground cloth, twenty-five feet of cord, tent tensioners, five aluminum stakes, two merino wool T-shirts, a long sleeve shirt, arm sleeves, thin gloves, three buffs, running shorts, tights, rain pants, three pairs of socks, warm hat, iPhone and charger, mini microphone, Sony RX100 with charger, four batteries, four SD cards, a GoPro with chest mount, pole mount, four batteries, five mini SD cards, various camera mounts, a USB charger, an adjustable camera mount, dental picks, toothpaste, toothbrush (attached to aluminum stake in case I need another), Gold Bond, moleskin, nail clippers, bamboo spork, extra cord (shoe laces), dental floss and a large gauge needle (for repairs on clothing, pack, and so on), razor blade, patch kit for sleeping bag and sleeping pad, dan moi (Vietnamese jaw harp), hiking poles (also helps with setting up tarp), lighter, sunscreen, lip balm, journal, pen (cut in half), Peace Pilgrim's Steps toward Inner Peace pamphlet (as though that will do me any good), credit card, driver's license, cash, checks, mini St. Jude (patron saint of hopeless cases), sunglasses, and some Velcro.

In all, the pack weighed about twelve pounds—much more than that and I would have had difficulty running under the load. I continued organizing the last of my gear, most of which I'd be using for the first time over the next few days. I set up a meeting in the morning with Breanna, who wanted to buy the car. I offered a discount if she'd be willing to drive Jared and me to the beach after she purchased the car and she agreed.

Breanna showed up precisely on time. She worked nights as an auditor at a hotel and had been waiting around. After a test ride and tire kick, we signed over the title and she handed me eleven hundred dollars. I handed thirty back to her of the wad and she drove Jared and me out to Folly Beach. We got out, shook hands, and parted ways.

I walked down through the sand to the waterfront. A man waved a metal detector about. Some folks fished from the pier. A couple laid out reading on a blanket. And all of a sudden, I felt very alone.

With a minimum of fanfare, I put the ocean behind me and started west.

The twenty-five-hundred-year-old legend of Pheidippides tells us about the Athenian soldier who ran from the fennel fields of Marathon to the Acropolis in Athens to announce victory over the Persians. He delivered his message and then died from exhaustion moments later.

I'm still not entirely sure why I'm doing this. To get to know myself? To get to know my country? At this point, I'm not certain I want to know either one all that much better. Shit. I'm already exhausted.

Maybe I am doing it because the runner is the messenger and his suffering must be witnessed.

Nah.

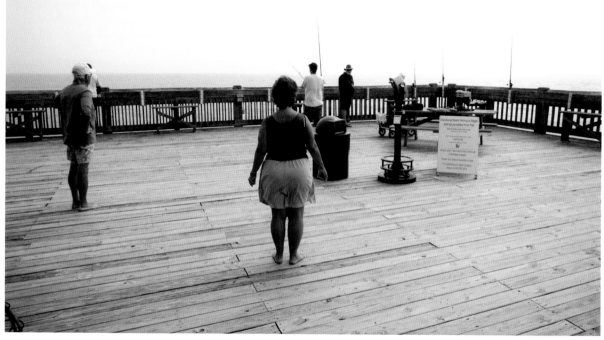

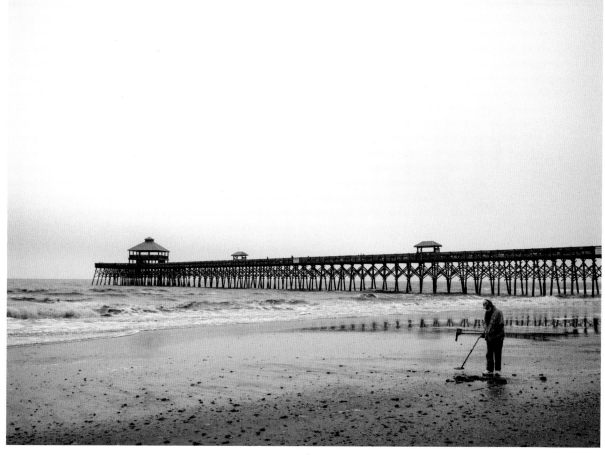

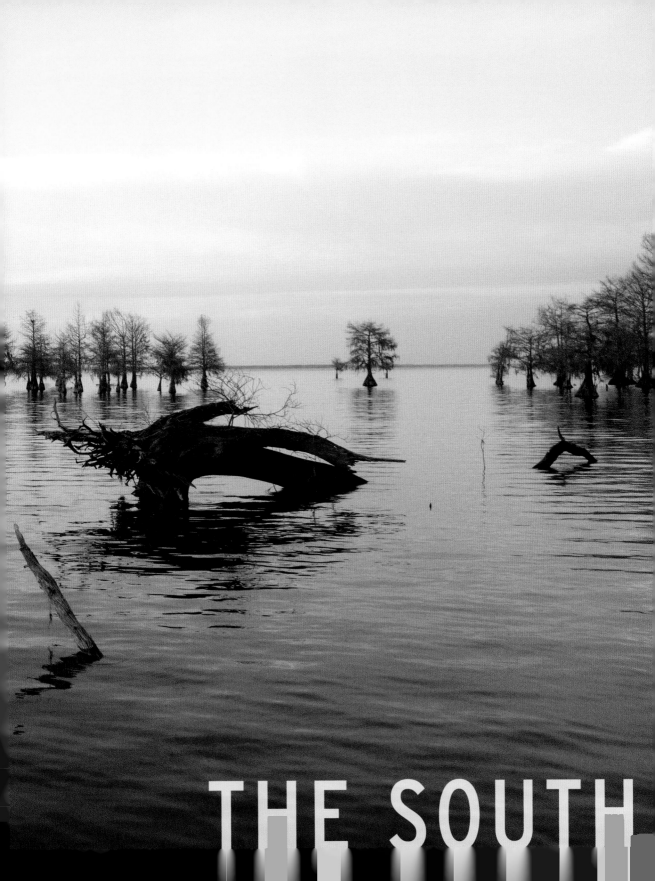

THE SOUTH

I sat down at an all-you-can-eat buffet in Prosperity, South Carolina. I had stashed my pack in the woods behind the gas station. Though I had been running for over a week, the trip was finally beginning to feel like it was underway since I was actually on my own now. I realized how wonderful it was to have had company during that first week. I sat there in silence and ate plate after plate of fried chicken.

After we sold the Corolla, the videographer, Jared, accompanied me with a rental car and all sorts of amenities that could never have fit into my bag, including my dear guitar. Jared is tireless, polite, and supremely qualified to do most any job. He went to bed after me and woke up before me. His presence was calming and encouraging and he saw to it that the beginning of this trip would not be entirely all pain and suffering.

On the fourth day, a friend whom I hadn't seen in ten years drove up from Florida and joined me on the trail for the next three days. I've known Geoff across continents and though our paths don't cross much, we keep tabs on each other. He had seen on Instagram that I was starting a journey that he had once undertaken on a bike and he wanted to see me off. Though Geoff hadn't run more than one or two miles in the months or years leading up to our reunion, he was CrossFit strong and ran right alongside me for ten miles, then thirty miles, and then thirty-two miles.

At a small intersection in the lowlands of South Carolina, I took a left and Geoff took a right. I looked over my shoulder and watched him hobble down the road, and suddenly felt very alone. This seventh day was when I felt the trip truly began.

So, there in Prosperity, amidst the neon and the plastic-covered tables and bottles of BBQ sauce, I sat alone in silence and took in the world around me. I got up to pay at the cash register but the woman told me that my dinner had been paid for. "Can I ask who paid? So that I can thank them?"

"You may, but I can't tell you."

I looked around the room and smiled, then shuffled out of the restaurant and into the woods behind the gas station. That would begin a connect-the-dots of generosity across my journey through the South: five dollars, five dollars, one dollar, one hundred dollars, fifty dollars. And the entirety of one man's wallet, which added up to $160. Meals were paid for, beers were bought, groceries given. Initially I turned down the generosity. I figured that I had saved my money. "I don't need it," I said. "I promise." But then I realized that it wasn't necessarily about needing the money. To some, it was out of a deep-seated need to give; for others, I felt that it was merely a way to participate in this massive journey. So I started taking the money and passing it forward. But sometimes, I would buy myself a beer.

The changing of accents from place to place is best observed at a walking pace, and for the first time in my life I recognized that a Southern accent could actually be one of several different accents that change from state to state, county to county, valley to valley. Across South Carolina, Georgia, Tennessee, Alabama, and Arkansas I listened to the *h* emerge from *what* and *bread* turn

into a three-syllable *bree-ay-ud*. Colloquialisms came and went with the breath that carried them.

On trails, train tracks, and highways, I made my way past the dismal swamps and uniform forests. The early spring provided me with several elements of surprise as I grossly underestimated the potential for chilly temperatures and precipitation. I woke to snow in the swampland and shivered through some dangerously frigid nights in the foothills of the Appalachians. For days upon days, I ran from gas station to gas station, hot chocolate to hot coffee, at one point stopping into a Walmart to supplement my wardrobe with an additional shirt.

Generosity and enthusiasm propelled me forward. Squished armadillos, flattened opossums, and the occasional dog decorating the highway generated a morbid curiosity about roadkill and what I would see next. Beside the road, the birds sang to each other. They sang springtime songs. The blood-red flicker of a cardinal passed through . . . its clean metallic chirp piercing through the woods.

I began my journey in the South not just because of the convenient weather—it represented a veritable void in my firsthand experience and understanding of the United States.

As I entered Moscow, Tennessee, the sheriff drove alongside me:

"You runnin' from the law?" He was an older black gentleman with a deep voice and a slow and precise accent. I slowed to a walk and offered a polite chuckle as I had assumed that he was joking.

"No sir," I said. "I'm just runnin'." I had picked up saying "sir" and "ma'am" almost immediately into my run. I liked the way it felt.

I walked toward the roadside BBQ joint that had caught my eye as I entered town while the sheriff continued to drive alongside me.

"You sure you're not runnin' from the law?" the sheriff asked again. It then occurred to me that he wasn't joking at all.

"No sir," I replied again. "I'm running across America."

"Are you carrying identification?"

I told him that indeed I was, at which point he asked to see it. I do not know much about the law, but I was pretty sure that he was overstepping his bounds. I let him know as much.

"You ain't from around here, are you?"

I told him that indeed I wasn't.

"Well, this is how we do things here."

As he called in my information to the dispatch, a small group of men formed at the roadside BBQ joint where I had my eyes and belly set before getting pulled over.

"You're all good," he said, as he handed my driver's license back to me.

"Yeah, I know."

"You eatin'?" he asked.

I told him that I had been planning on it.

"Well, I'm buyin'."

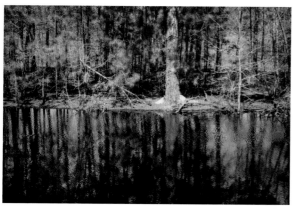
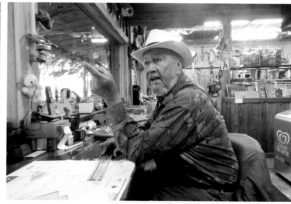
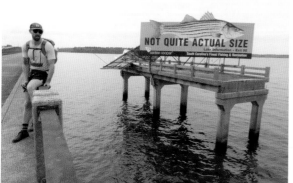

**Francis Marion National Forest,
South Carolina**

"I like to come here in the springtime when
the water is flowing," he said. "There's a
spot down the hill where, when the water
is moving swift enough, it makes a
beautiful trickling sound."

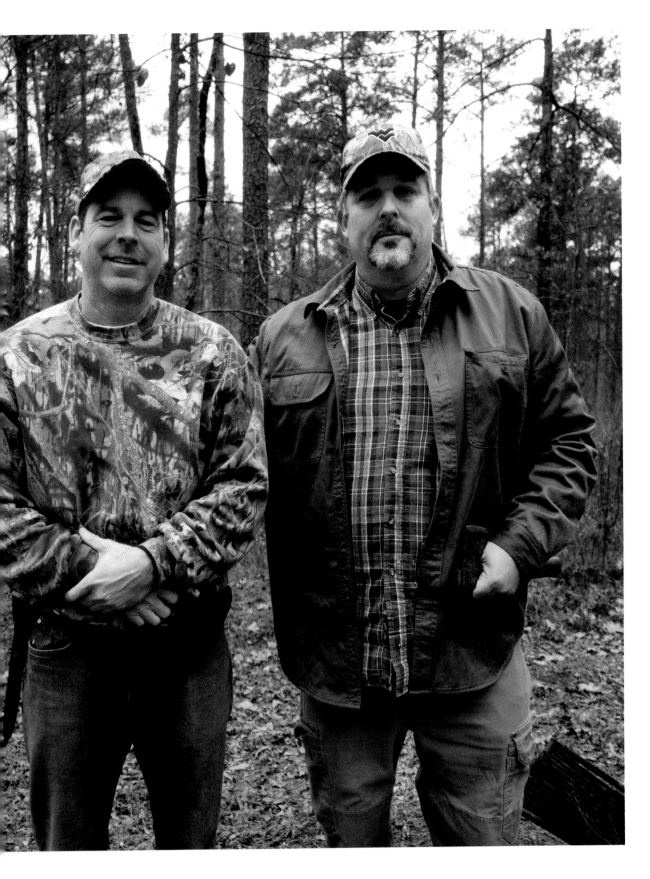

DAY 10 ◆ MILE 227

Newberry, South Carolina

Kathy was making biscuits and burgers at a gas station at the edge of town. She had a smile, a kind face, and could see that I needed a boost. She told me about how a couple months back a young woman came in looking like she needed a hug: "Can I give you a hug?" Kathy asked her. And the woman accepted. And cried. And returned the next day and asked if she could call her Ma. And returned day after day for a hug from Ma. The manager of the gas station walked in, looked at my gear spread on the table, and told me I had to go. Kathy mouthed, I'm sorry, from the kitchen window. She came over, gave me a hug, and I cried. I didn't know I needed a hug. She did though.

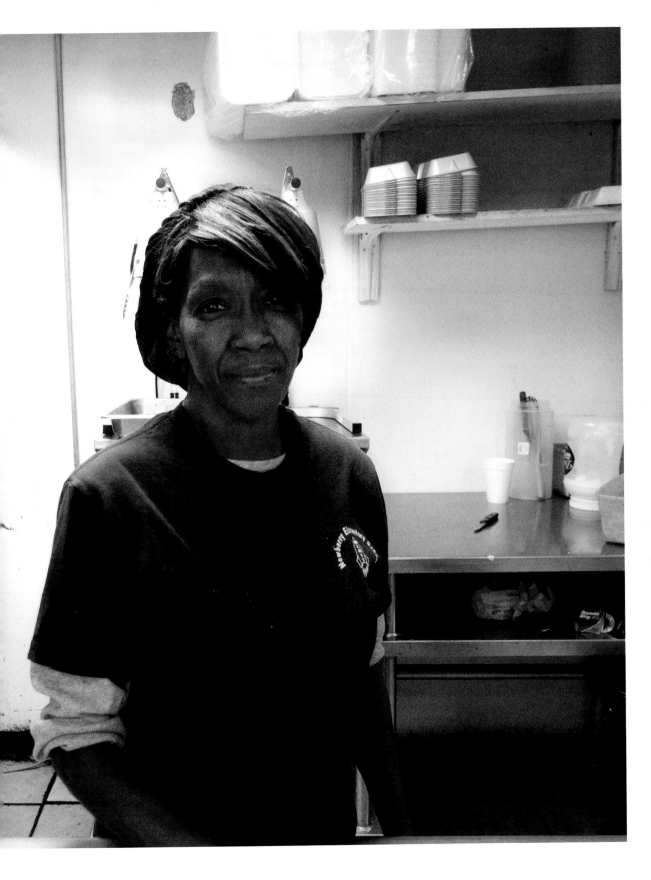

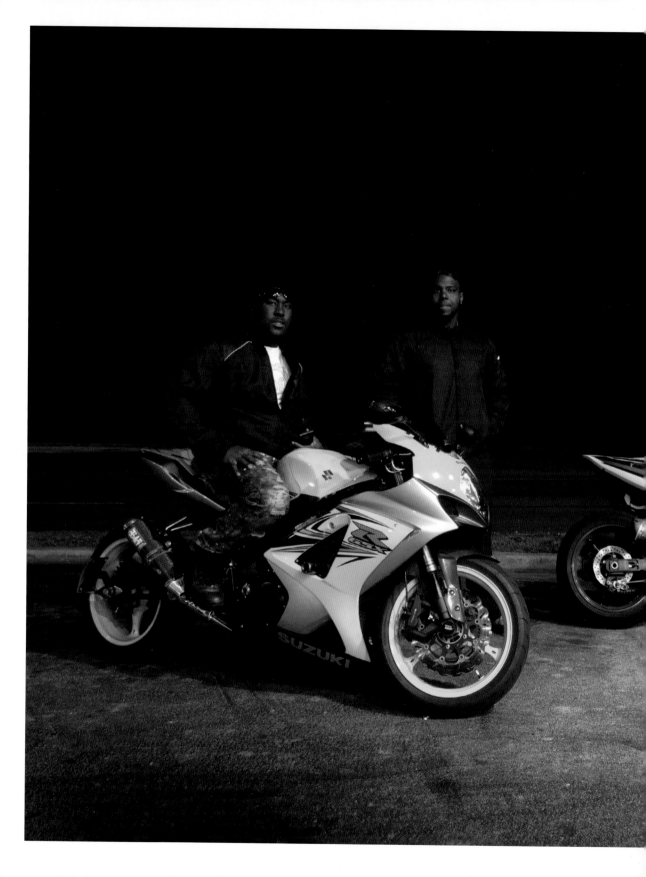

DAY 10 ◆ MILE 247

Prosperity, South Carolina

When I asked if I could take their photo, it occurred to me that my props, the costume that allowed me to tell my story of running across the country, were stashed in the trees behind the gas station. Without a backpack, I was just a guy in strange running clothes lurking around the pumps after dark.

"Why?" the man on the right asked.

I told him the only thing I could think of, the truth. "Because you guys look bad ass."

He muffled his laugh. "Yeah," he said. "Okay."

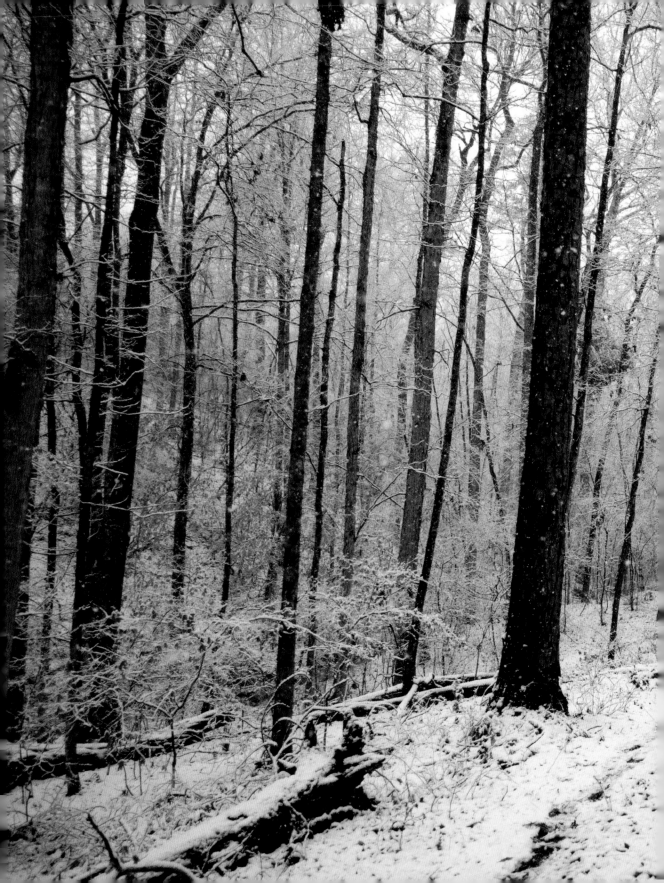

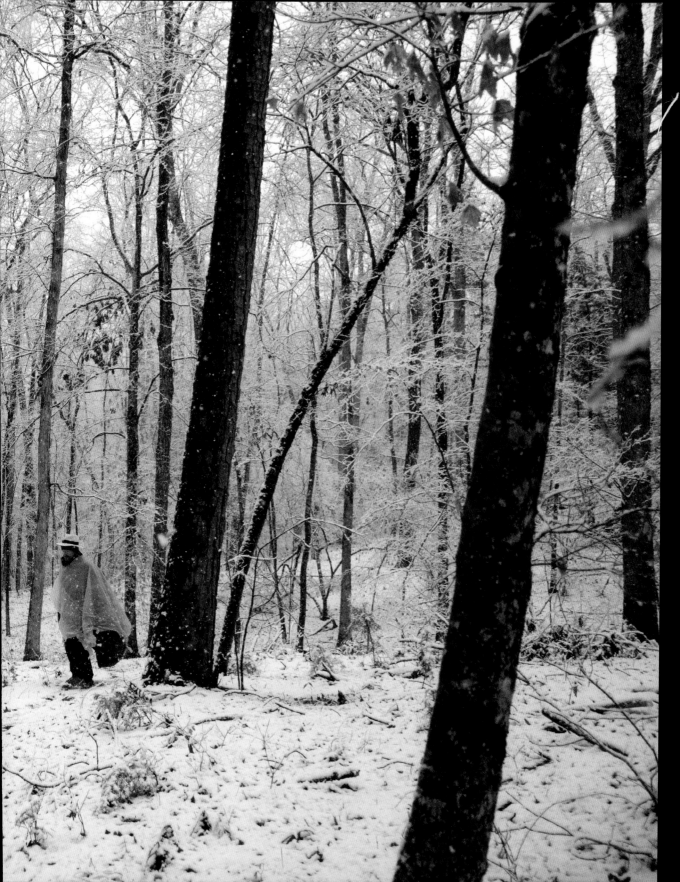

Princeton, South Carolina

When I came upon David, he was hard at work, spraying weeds. He's from Guatemala but is married to an American here with whom he has two kids, a boy and a girl. It's been sixteen years since he's seen his parents. He's hopeful he'll get papers soon that will allow him to go visit his folks. He asked if he should put the sprayer down for the photo and I told him that that was part of the photo. "Okay. Then my shoes too, please."

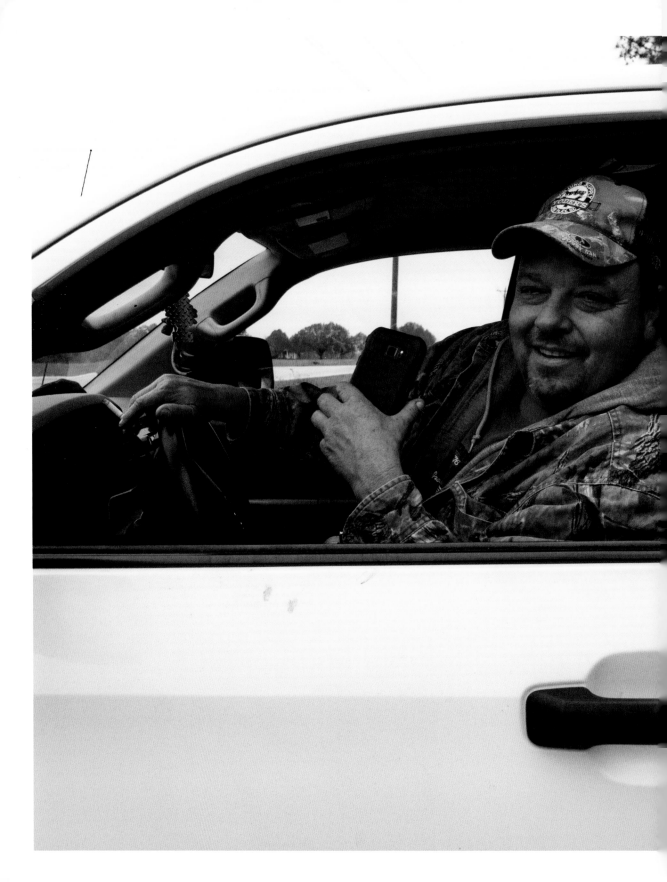

Walhalla, South Carolina

I came upon Bubba talking to his sister
Julie on the phone. "What on earth you
doin'?" he yelled at me. I told him
about my trip. "I saw you runnin' at me
and nearly grabbed my pistol! There
are some crazy people out here! Julie,"
he yelled into the phone, "this man is
running across the country!" . . . "Yeah!
Like Forrest Gump!" He told me to be
safe. Warned me of the impending
snow and of the wild hogs in the
woods. "Boy they'll tear you to pieces!"

DAY 23 ◆ MILE 546

Chatsworth, Georgia

"I had a stroke 'bout six years ago.
I can't walk more than one hundred
feet, much less run 'cross the country,"
Mr. Klein told me. He had finished
telling me about all the fish he'd
caught earlier that day, lamenting his
condition and denouncing those that
he knew were well over their limit.

"Well, at least you got your eight-
fish limit," I said.

"That's right," he replied.

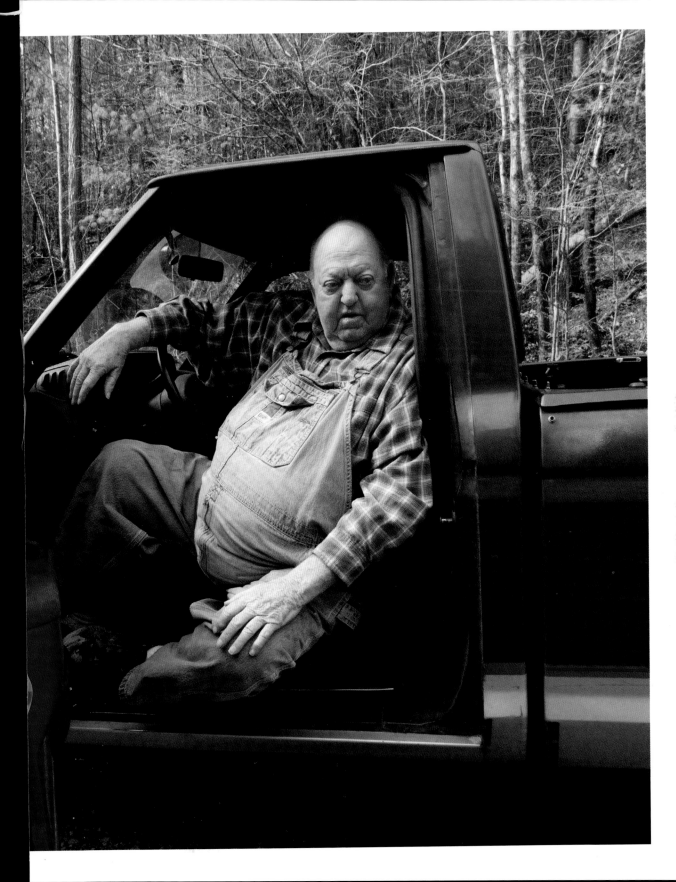

Rossville, Georgia

"You out here every day?"

"Every day it's not raining or cold," Octavia said.

"I'm from Colorado. What's cold?"

"Well I'm from Cincinnati." We had a silent standoff, neither acknowledging which cold was colder.

After I declined to purchase any of her goods she wished me well. "Stay safe on this road. Lot of drugs. Pill poppers, needles, meth. Stay safe."

Saulsbury, Tennessee

"Of course you can take my picture!
Lord knows everybody else does." Roy
Williams is well aware that he's a
handsome man. He took a cigarette
break from fixing a lawnmower tube.
"I should charge double for these tubes.
They're a pain. I should be inside
mopping and fixing the shelves. And
there's a bunch a bass in the lake
calling my name."

 "You got things to do."

 "That's right," he laughed and took
another pull from his cigarette.

Ramer, Tennessee

I ordered two eggs over easy with hash browns and toast.

"What meat would you like?"

"No meat."

She paused and looked at me over her notepad.

"What kind of bread would you like?" *Bread* is a three-syllable word from Stacy. Like *bree-ay-ud*.

"We have white *bree-ay-ud* and wheat *bree-ay-ud*."

As I left, Stacy told me to wait. "I have something for you," and she handed me a Ziploc bag full of biscuits. "What's he gonna do with all those biscuits?" Anita asked. "I don't know. Eat 'em, feed the birds. I don't know."

At the edge of town, I kept one biscuit and fed the rest to the vultures who seemed to be more interested in a freshly squished opossum.

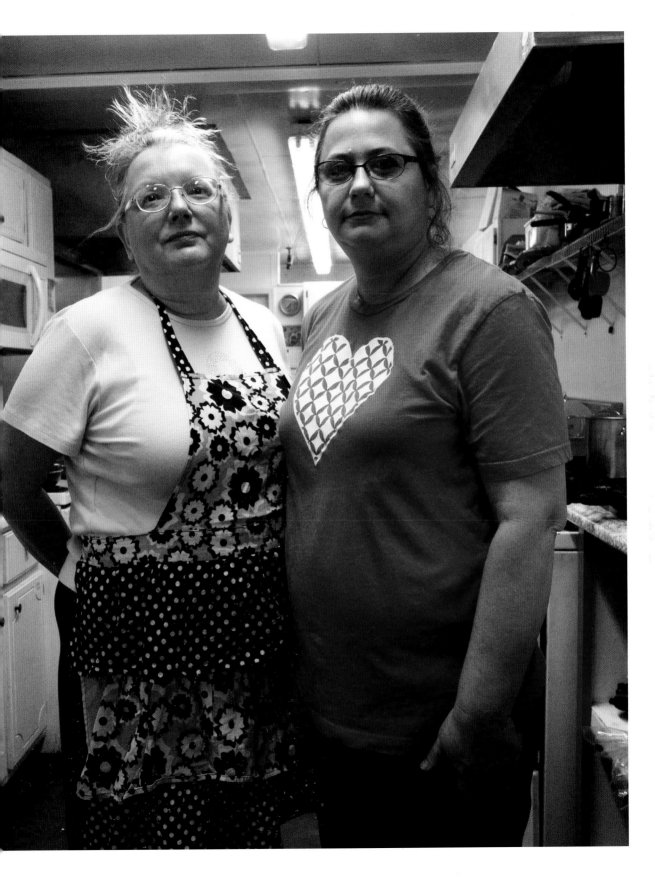

Earle, Arkansas

Langdon was waving at every car that
passed going toward him and stuck his
thumb out for every car from behind.
I crossed (Highway 64) to chat with him
for just a moment because I know the only
thing more difficult than getting a ride in
the middle of nowhere is two people
trying to get a ride in the middle of
nowhere.

"I'm gonna go see if I can get thrown in
jail in a different county," he said with a
defeated smile.

"You just get out of jail?"

"Yeah," he said, still smiling.

I noticed his empty water bottle.
"You need water?"

"No, I'm okay."

"Food? I have some granola bars."

"Yeah, Mr. Gates. I'm starving."

I gave him a few bars and wished
him luck.

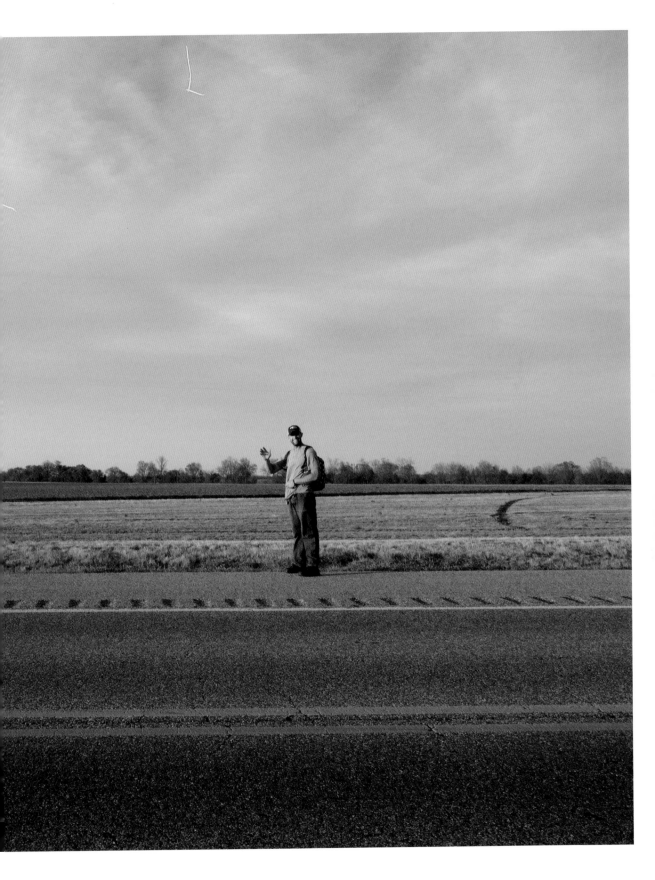

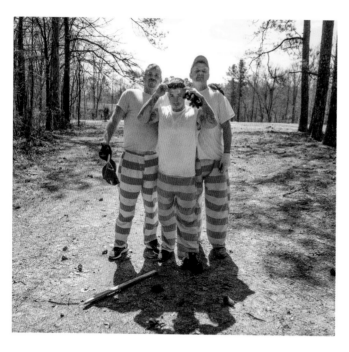

DAY 22 ◆ MILE 526

Varnell, Georgia

With my earbuds blasting the Grateful
Dead, I nearly didn't hear them yelling at
me from the side of the road.

"You know where you are?"

"I'm still in Georgia, aren't I?"

"Whitefield County. Correctional facility.
We're inmates."

Shorty, David, and Kelty were out in
front of the complex doing some light
yard work when I passed by. They had
been entrusted with a chainsaw and other
blades, so I assumed they were harmless—
in for a DUI, tax evasion—and Kelty
wouldn't say.

"Colorado!" Kelty said, when I told them
where I was from. "You got any of those
Colorado smokes!?"

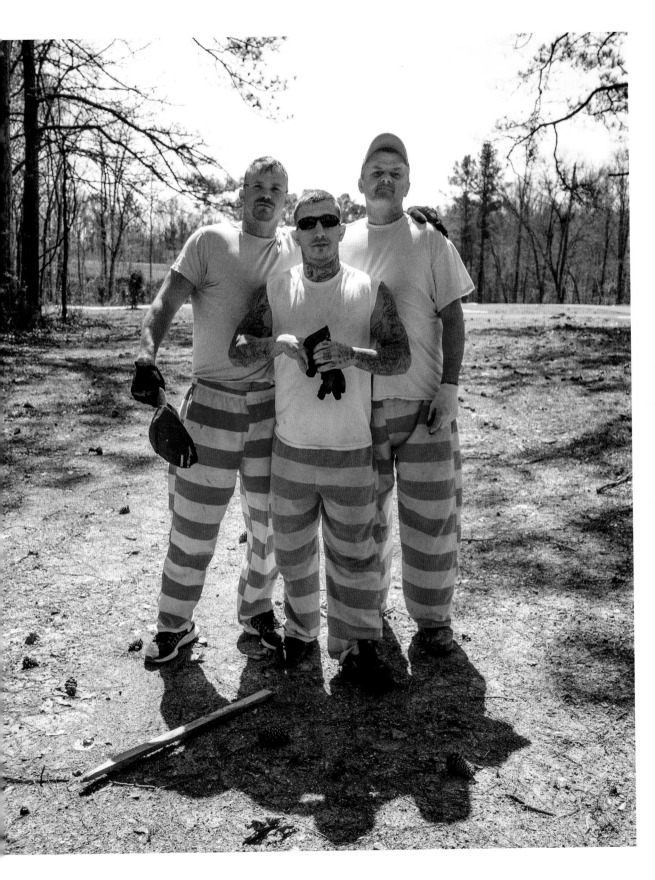

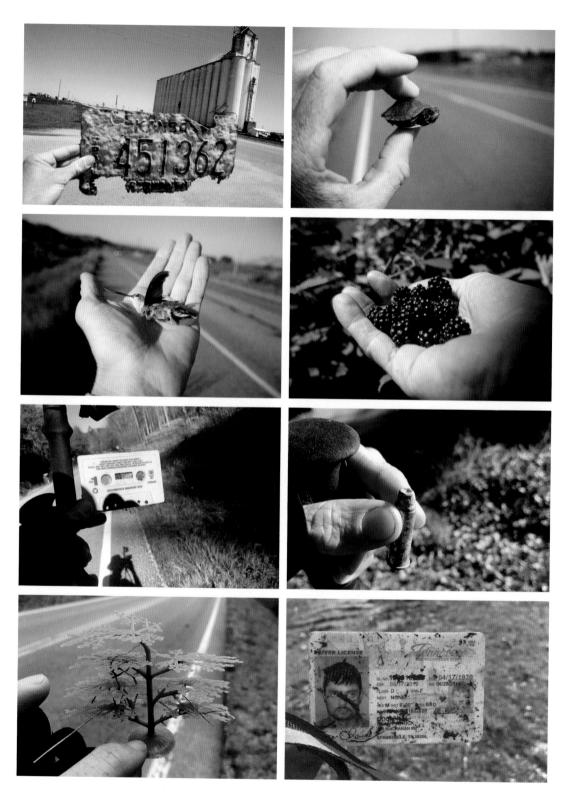

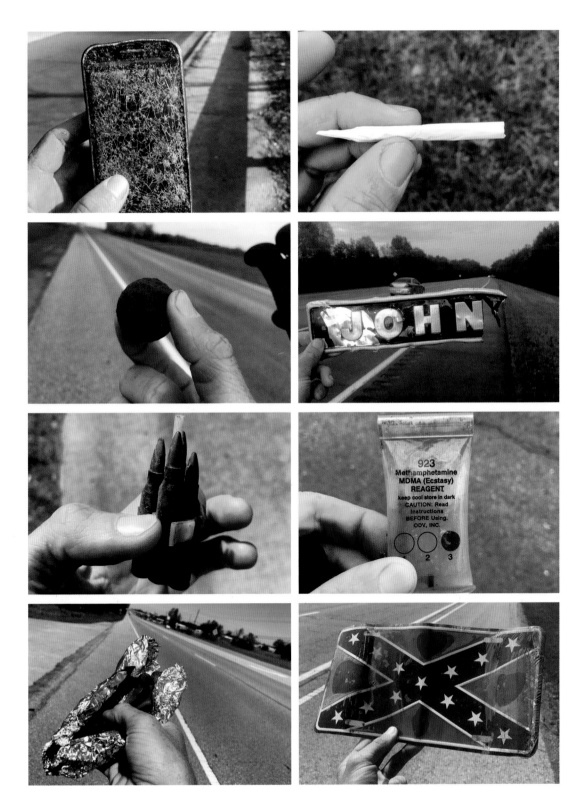

Memphis, Tennessee

"Yeah, you can take my picture. But don't expect me to pose. Or look at you," Kayleigh said.

I caught her on her cigarette break after serving beers to fifty thirsty cyclists. "What's the chemical compound?" I asked, nodding to the tattoo descending across her chest. "Oxytocin. The love drug. It's naturally released following childbirth to help a mother fall in love with her baby. And not eat it."

DAY 41 ◆ MILE 1,009

Barker's Cafe

McCrory, Arkansas

Wherein I ate entirely too much meat loaf at the all-you-can-eat buffet, organized all my belongings, and did not get in trouble for cussing.

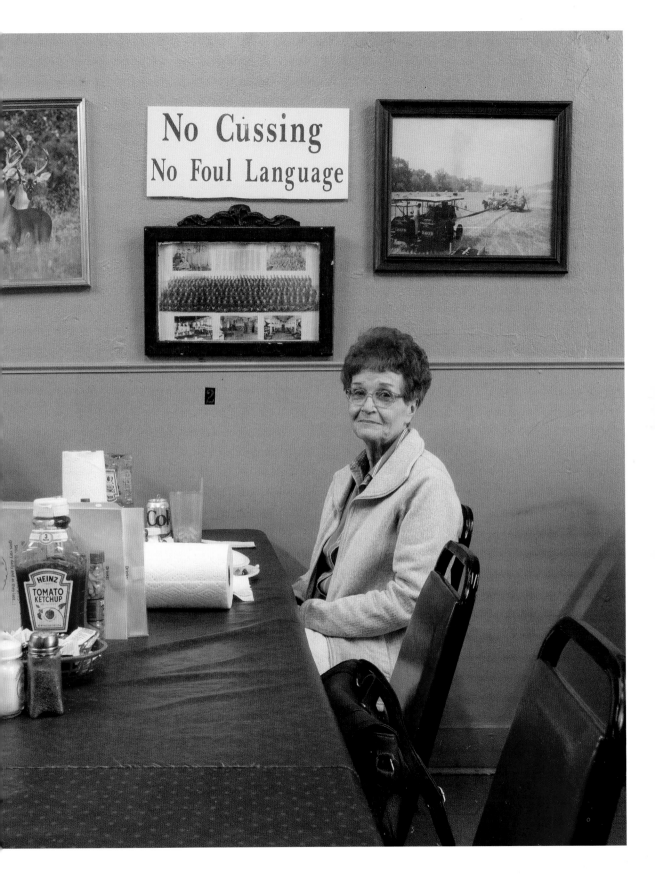

THE
APPALACHIANS

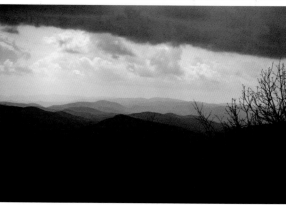

"Forrest Gump! That should be your trail name!" he said with a thick Bostonian accent.

He was covered in tattoos. Up his arms, around his neck.

"No. It shouldn't," I said.

He laughed. "Somebody tried to give me the name 'Tat.' I shot that down too. Till then, I'm just Josh."

Around the campfire was Tic Tac, Bull Frog, Broken Arrow, Elvis, and a young woman named Bob. They beamed with pride over their trail names. To have a trail name, I thought, is to commemorate one's time lived as a different person. It both represents a part of who you are to your fellow hikers and remains a symbol of who you were when you return to the "real" world. I thought it was silly. Why couldn't I just be Rickey and Josh be Josh? I would later learn that having a trail name can be rather useful when it comes time to compartmentalize the person I was with the person I have become.

Josh showed me his knuckles. SELF MADE was written in blocky typeface across his eight fingers. "My mom hates it," he said. Imitating his mom with an even thicker Bostonian accent, he said, "'I was in labor for thirty-six hours with you and you have the nerve to claim you were 'self-made.'"

"You headed to Katahdin?" he asked.

I explained to him that I had just gotten on the trail. That I was heading south, which was actually west against the spawning northbound hikers. That this was just a small portion of the longer trip I was doing.

I would be on the Appalachian Trail for eighty miles—a short section of the National Scenic Trail's full twenty-two hundred miles. As the community of hikers headed steadily northward and the miles built, some chose to stop while the rest of them forged on. There, in the beginning, a few seasoned hikers preached to the large audience before them, an audience characterized by apprehension, excitement, and perhaps a little bit of fear. It is an amazing thing to set off on a five-month adventure, whether along the Appalachian Trail or across the country. I saw a version of myself two weeks earlier, wide-eyed, full of energy, and perhaps a little bit scared.

I had been on the road for nearly two weeks. With four hundred miles behind me, I had developed a routine of eating, sleeping, and running. A first round of blisters had come and gone, leaving hardened callouses in their place. With some thirty-five-mile days behind me under some rather unpleasant conditions, I was feeling confident that I could keep up the pace.

I had hoped to grab a spot in the shelter, which was little more than a raised wooden platform, three walls, and a roof, but due to the early season busyness of the trail, not only was there no room in the shelter, there was hardly any room in the overcrowded little camp to set up my tarp. In a camp that wasn't meant for much more than twenty people, there were close to fifty. I did see a spot though—one that I normally wouldn't have seen had I not been improvising my camp spots for the previous couple weeks. Beneath the floor of the shelter was an additional couple of feet of open space above the dirt. The rain fell through the night as I slept soundly beneath a dozen other thru-hikers.

I carried on in the morning through a cloud layer resting in the trees. Cold and wet, I climbed and descended over treacherous footing, up and down for hours and hours. The miles were challenging but simple. White blazes marked the trail every few hundred feet. Though commonly referred to as the Green Tunnel on account of it being largely overgrown with vegetation, the Appalachian Trail in March provided mountaintop vistas where the greenness of life was still at bay. On the forest floor, a carpet of leaves from the previous year rested, awaiting its steps in decomposition and rebirth.

Follow the white blazes.

Follow the white blazes.

Kind people called Trail Angels appeared at road crossings giving away cheap, sugary food, fruit, and occasionally hot chocolate. On-trail hostels offered food bins to give or take any extra food. I learned quickly that I didn't need to purchase any food on the trail. In fact, I hardly had to carry any food with me.

I had heard that a trail angel, Catman, was hosting an all-night bonfire down the trail. I made it there just after sundown to find that he had brought thirty cases of beer, thirty pounds of hot dogs, hot chocolate, and bacon from somewhere up north. He was a big guy and didn't look like he could hike very far, but apparently he hiked the whole thing with a cat on his shoulders a few years back. The cat died from diabetes a couple years later, and now Catman makes the pilgrimage once a year to encourage the hikers and revel in their company.

"Trail name?" he asked me.

"Trail Name," I said, trying it on, despite the taboo of giving oneself your own trail name.

He paused. Then smiled.

"Here you go, Trail Name," he said as he handed me a beer.

In the morning, I woke as the camp began to disperse except for Catman, who was still sitting by the fire with a beer in his hand and a big smile on his face. I sat back down and we drank till noon before I realized that it was going to be hard to get to Springer Mountain before sundown.

I stumbled down the trail, against the stream of hikers, past big hopes and dreams, apprehension, fear, and the distinct possibility of failure.

I stumbled down the trail looking at myself.

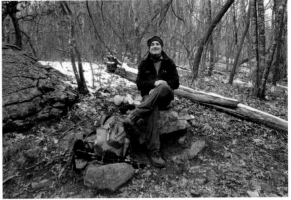

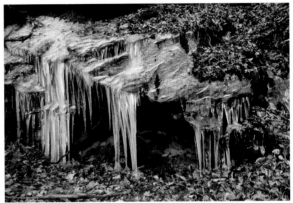

Clayton, Georgia

"How you doin', bud? I'm Lonny Hamby."

"I'm Rickey," I said, and shook his hand.

"Rickey what?"

"Rickey Gates. Nice to meet you, Lonny."

"Hamby."

"Nice to meet you, Lonny Hamby."

"Nice to meet you, Rickey Gates."

And then he let go of my hand.

Lonny Hamby on the far right.

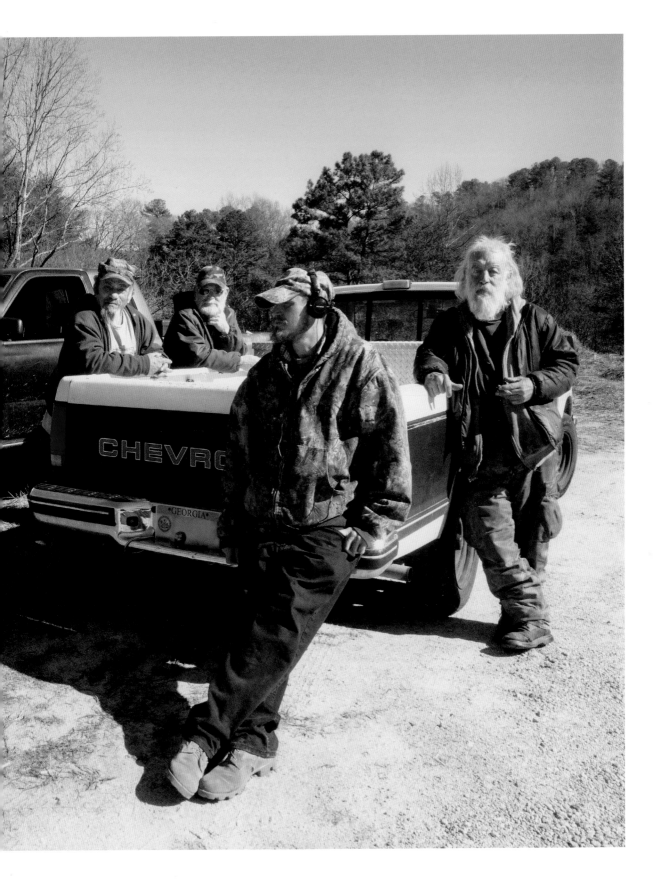

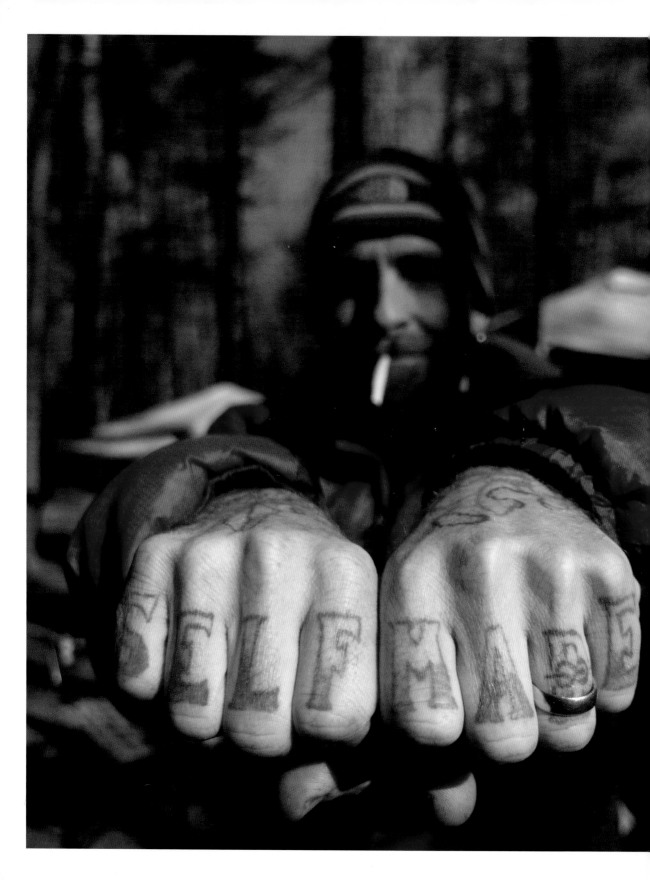

Gooch Gap (Appalachian Trail [AT]), Georgia

"My mom hates it," he said with a thick Bostonian accent. "I was in labor for thirty-six hours and you have the nerve to claim you were 'self-made'!?" he imitated his mother.

"What's your trail name," I asked him.

"Somebody tried to give me the name 'Tat.' I shot that down. . . . Till then I'm just Josh."

DAY 19 ◆ MILE 458

Low Gap Shelter (AT), Georgia

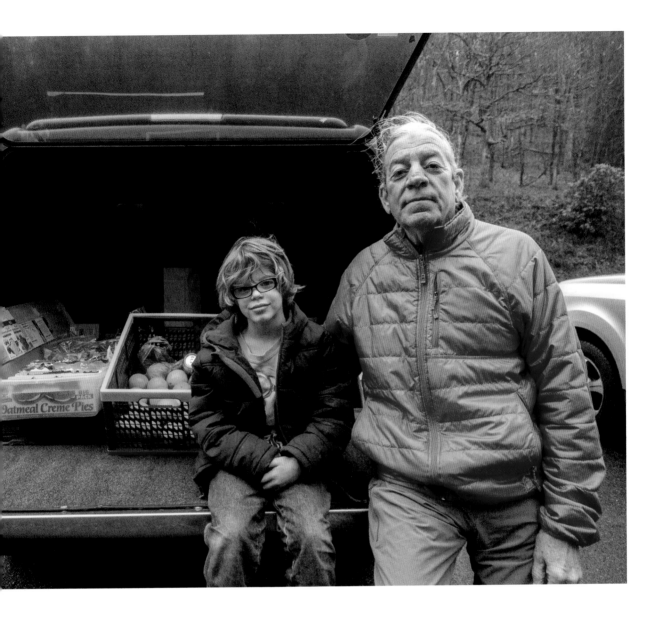

Unicoi Gap (AT), Georgia

Lion Heart and Happy Feet were handing out food to the thru-hikers at a road crossing in northern Georgia. Though I tried my hardest not to overindulge, I managed to fit a Nutty Buddy bar, an Oatmeal Creme Pie, a banana, and a Yoo-hoo into my belly before carrying on.

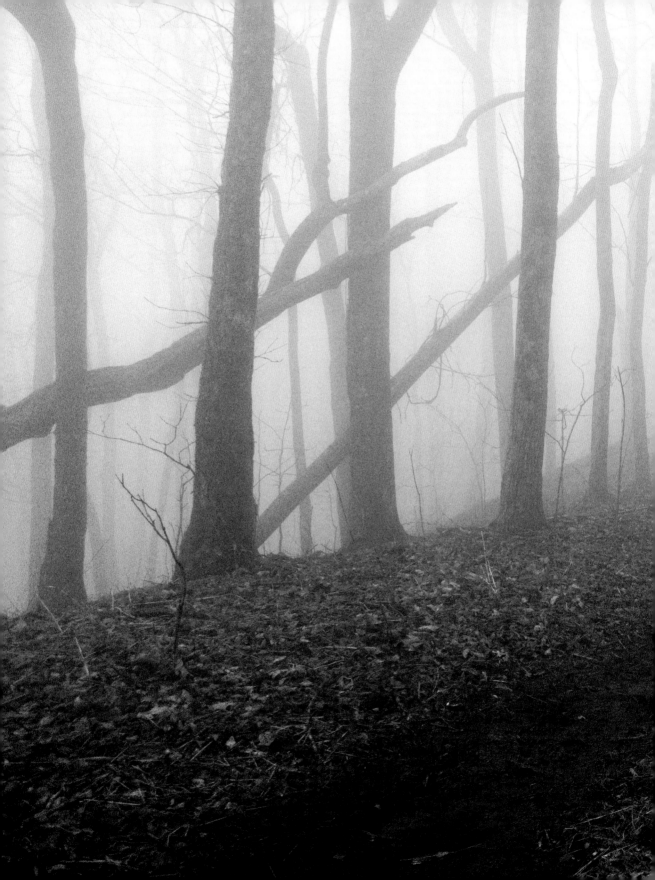

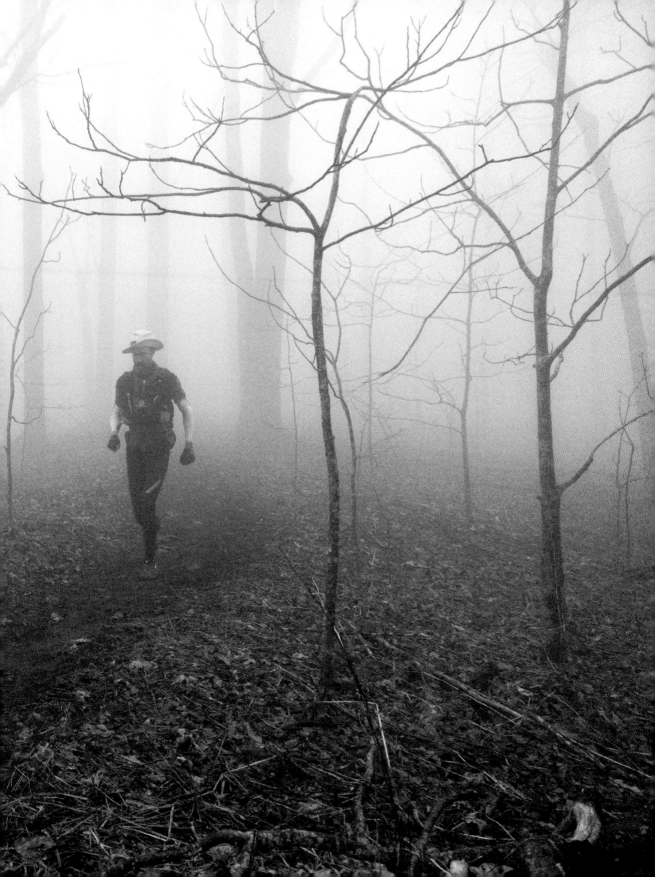

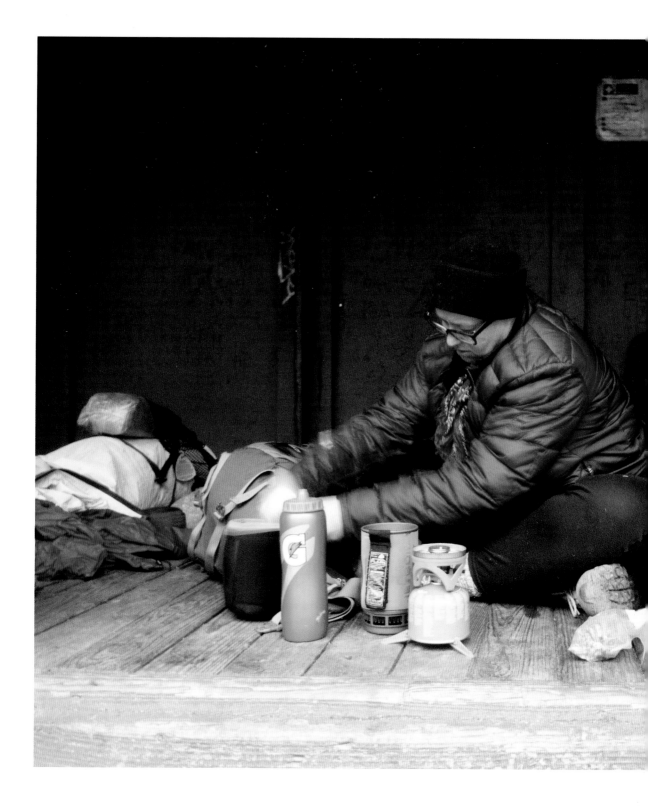

Low Gap Shelter (AT), Georgia

When asked if there was any room left for one more person in the shelter, the evening's habitants were quick to spread out a little bit more while offering a weak apology for the lack of space.

THE RIVER

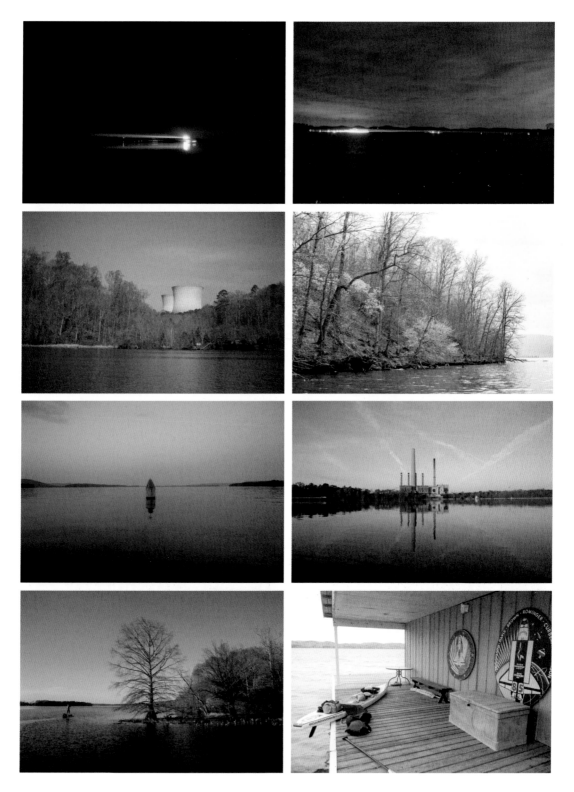

South Pittsburg, Tennessee

Bob Kellerman's great-grandpa started Lodge Cast Iron along the banks of the Tennessee River one hundred years ago. You've cooked your eggs in these pans. I was drying my stuff out in Bob's riverfront lawn when he came over and introduced himself.

"You're that skinny boy running to San Francisco!"

He'd read about me in the Chattanooga newspaper. He drove me to the office, introduced me to the staff, bought me lunch at Steverino's, and had me back at the river in an hour. After forty-eight years in the business, he's about to hand the business over to his son.

"Time to move on to other things."

"Like what?" I asked.

"I want to see some of the Great Rivers." He listed off the Nile, Amazon, Yangtze, and others. "Which one do you think?" he asked.

"Amazon," I said.

Counce, Tennessee

"I've been on the river for the past ten days. What should I eat?" I asked.

"WTF," she said.

"Sorry?"

"Get the WTF. The half order. You won't be able to finish the whole."

"Bring me the full WTF."

After 250 miles of Slim Jims, Gummy-O's, Pop-Tarts, and salted peanuts, a profanity laced lunch special was just what I needed.

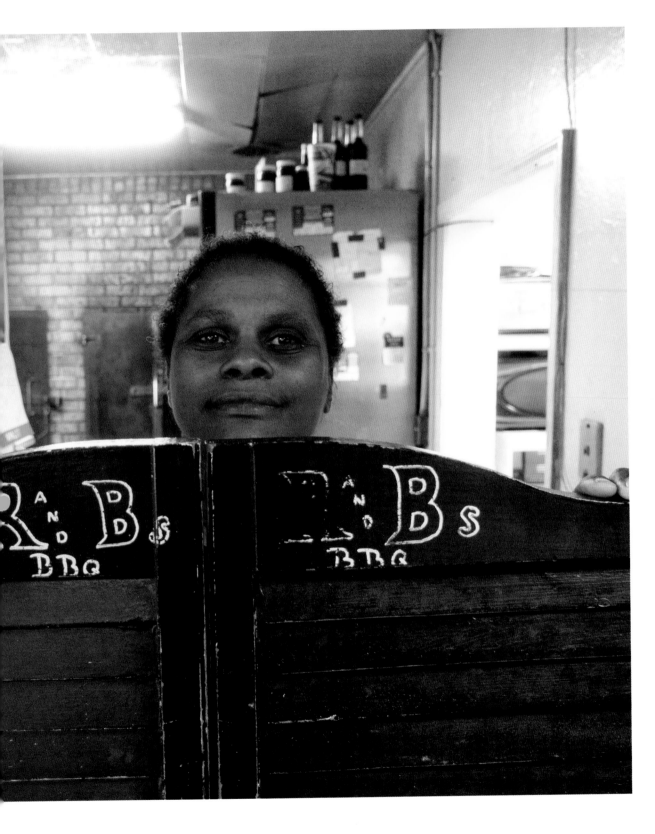

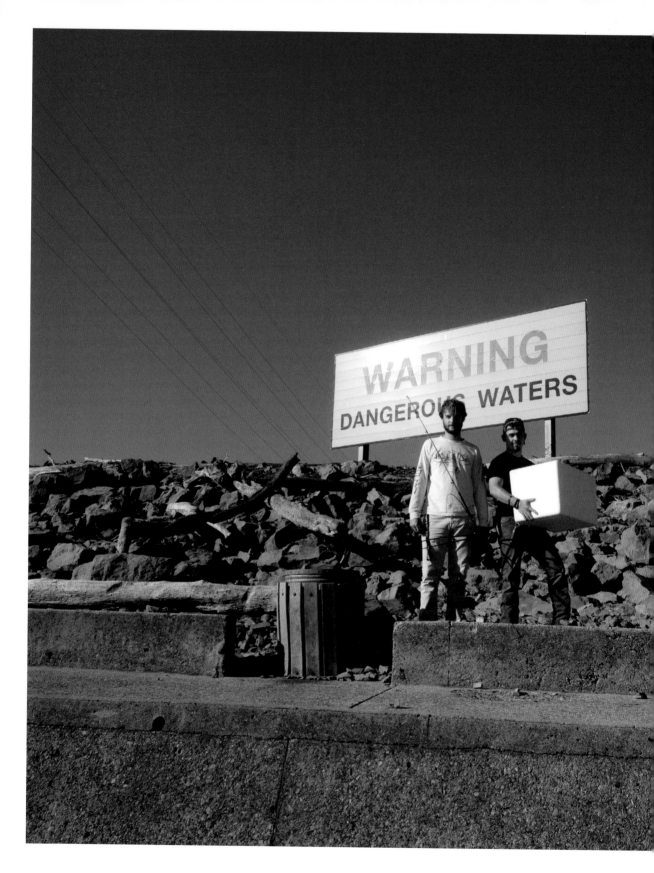

Guntersville, Alabama

"How was the fishing?"

"Alright. Mostly drinking."

Of the four people I asked to take their portraits along the water, only these two agreed. The others said that they didn't want a photo to line up with a mug shot.

Counce, Tennessee

Randy loaded the stand-up paddle-
boards in the back of his truck for the
long drive back to Chattanooga, but
not before giving me a quick juggling
lesson. He was full of all sorts
of surprises.

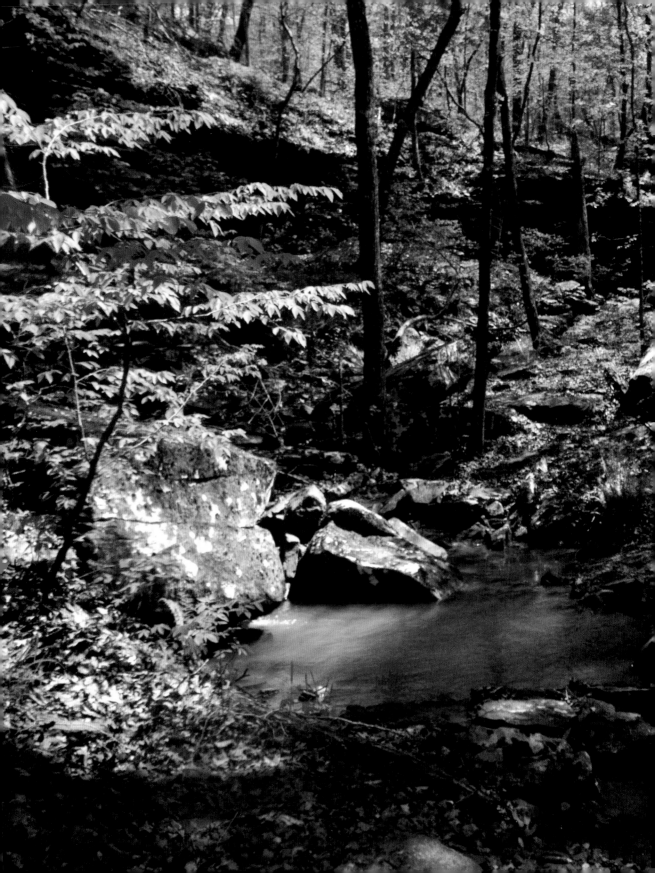

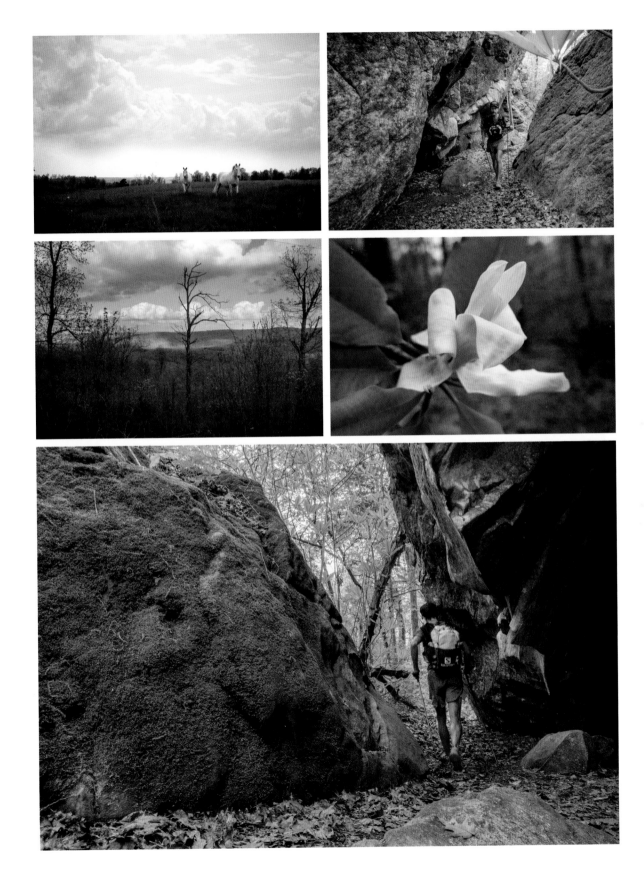

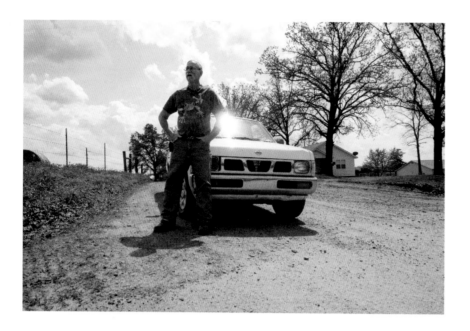

DAY 41 ◆ MILE 1,017

Quitman, Arkansas

I was halfway between Quitman and Gravesville on the 124, lamenting the hundreds of miles I'd spent on the shoulder of the road and the hundreds more to come; my feet hurt and the heat was getting to me, and it wasn't that hot. Which was also getting to me. "You (in Arkansas *you* is pronounced and stretched out to *eeyou*) runnin' cross the country or something?" A man yelled at me from his pickup as he slowly drove by.

"As a matter of fact, that's exactly what I'm doing."

"I want to talk to *eeyou!*"

Jim Steel was waiting up the road for me. "I want to donate to your cause."

I told him that I didn't really have a "cause."

"Well then I want to donate to *eeyou*."

I told him I really wasn't in need of money. That I'd saved up plenty before the trip.

Jim insisted. "As *eeyou* can see I've been pulled out of a ditch recently." He pointed at a needle port in his arm and I wasn't sure if he was talking about a figurative ditch or literal ditch, "and it would mean so much to me if *eeyou* just took this money."

I took the wad of cash from his hand and thanked him. "I'm going to pray for *eeyou*," and with that he got in his car and drove off.

I decided shortly after Jim Steel put $160 in my hand that I would pass it on down the road. Jim Steel's eight Jacksons. I liked the sound of that.

Oh, and my feet stopped hurting.

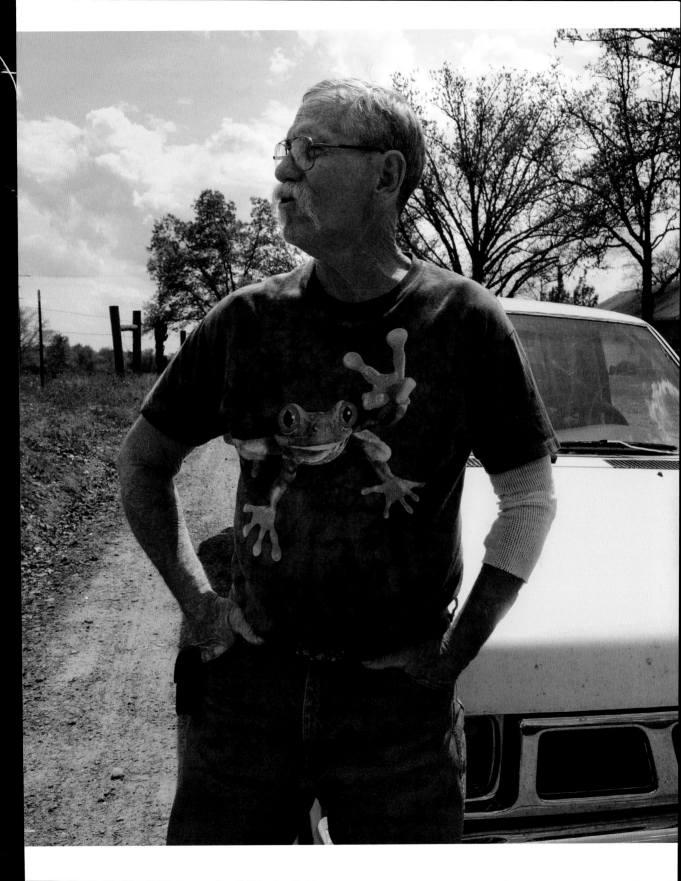

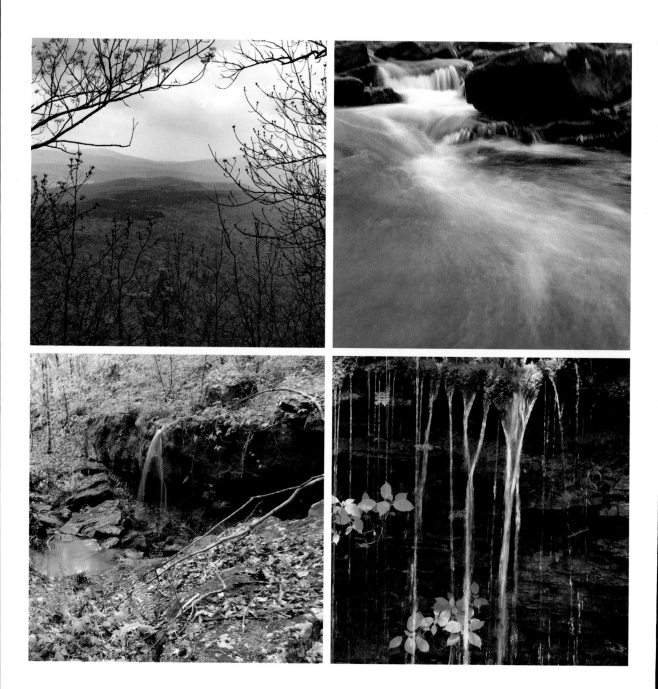

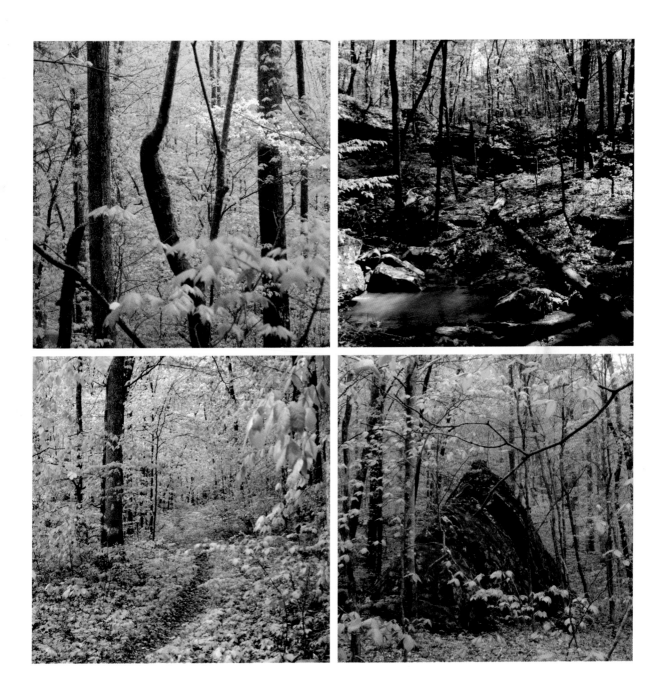

Tilly, Arkansas

There was an article on the wall from
1992 with the headline "Postmaster
Keeping Style" or something like that.

"Marylyn, this is great!" I said. It was
the only thing in the country store/
post office that pointed toward the
woman who had run the place as
postmaster for thirty-three years and
store clerk for the past ten. She was a
little embarrassed that I'd found it but
quickly looked out toward the light as
though she was again being photo-
graphed. "I used to love dressing up.
I had so many clothes, you wouldn't
believe."

The photos showed a handsome
woman in her thirties in pantsuits,
long skirts, blouses with shoulder
pads, and other fashion-forward
clothes—especially, I thought, for
rural Arkansas.

"When my husband passed in '03
that put an end to buying so many
clothes. You know it cost a lot of
money, those clothes."

When I asked if I could take her
picture, she said, "Oh my," and quickly
tidied up her desk and hair.

She subtly flashed several different
poses in just as many seconds.

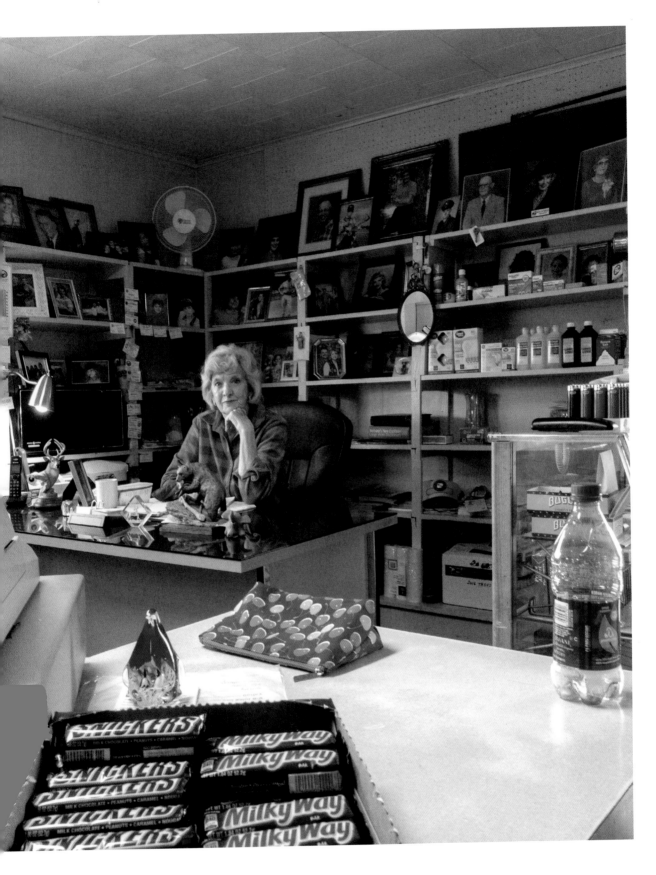

Farmington, Arkansas

"Hey!" He yelled at me from his front door. "Hey, come 'er!" Randy ran inside and came back out with a cup of black coffee in a Waffle House mug. "I seen you runnin' back there when I drove by. I don't know what you're looking for but maybe this will help. You take sugar?" I told him I did. He ran back inside and came back out with the coffee again. "You must have really pissed off your old lady. I done that. I know." He handed me the coffee and said again, "This ought to help."

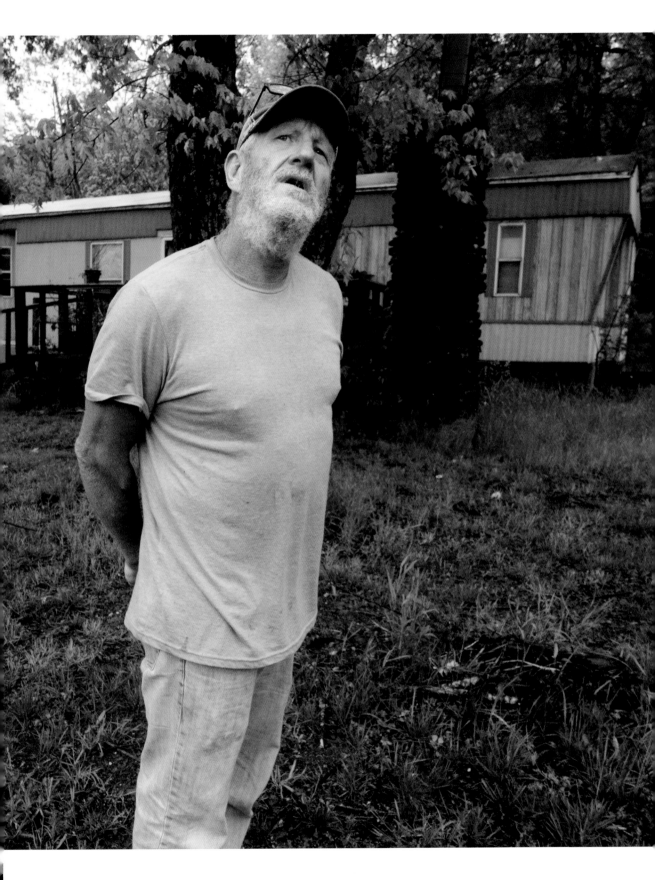

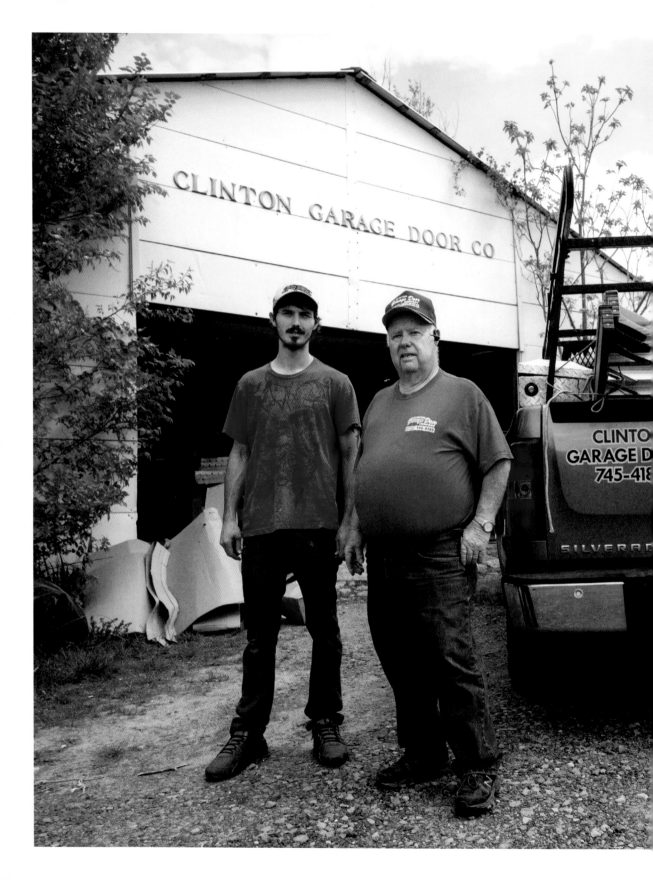

Crabtree, Arkansas

"People are different up here, let me tell you. I been here twenty-five years. Came up from Little Rock." Jonny Jenkins spoke quick, like he was trying to sell me something. "People was waving at me. I don't know you! But that's just how they are. 'Cept over in Alread. There was a murder there few years back. Couple guys killed an old lady. Chopped her up and spread her out all over the place. Police came after them and one of them killed a cop. I tell you, I never seen so many sirens in my life after that. They sent the Calvary after 'em. But can you believe, one got away. They finally did get him up near Fayetteville. Which way you headed?"

"Alread."

"Well, we best be letting you get to your hike, otherwise you'll be walking in the dark. And there's bears out there."

Mr. Jenkins went on about the bears for some time while his assistant James Hobbs agreed with everything.

DAY 49 ◆ MILE 1,234

Ozark Highlands Trail, Arkansas

Billy Simpson is the youngest sixty-
year-old I've ever known. I don't know
how he made his money, but he
doesn't have to work anymore. So he
chased me around and showed me
the way.

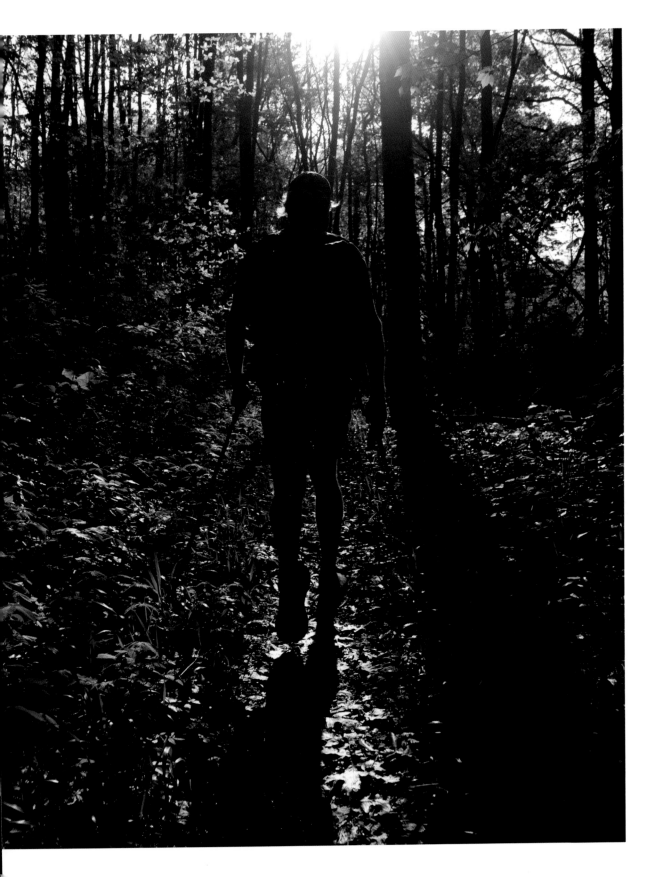

Fayetteville, Arkansas

Jim Steel had recently given me $160, and I, even more recently, had decided I'd give it all away. I offered this gentleman twenty of those dollars in exchange for a portrait. It didn't feel good to me, and I'm pretty sure it didn't feel good to him either. The rest of the money was given away without exchange.

133

THE
GREAT PLAINS

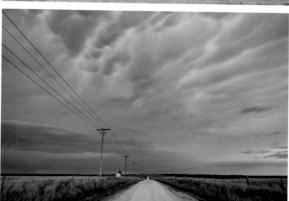
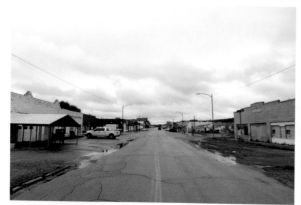

I showed up late at The Refuge and asked the bartender if they were still serving food. I wouldn't have been surprised or annoyed if they weren't; I just didn't want to go three more blocks just for more gas station food. She looked at me and asked how many burgers I'd like and went back to the kitchen to fire up the grill and get the fryer going again.

I sat quietly in the corner, drinking my beer and shoving handfuls of french fries in my mouth, while a group of folks in good spirits sipped their beers and picked on each other about this and that.

Arriving in Stafford, Kansas, that evening marked my longest mileage day of the run so far, at forty-two miles—thanks in large part to having started my day at three in the morning when the train from Wisconsin dropped me off in Hutchinson. I had taken a northbound train to Wisconsin a week earlier to celebrate Liz's Master of Fine Arts Show, an exhibition of her thesis sculpture. Publicly, we pretended that nothing had happened. Privately, we were still very raw and fragile from the breakup, the distance, and our individual pursuits that were commanding every bit of our energy.

I stayed in Madison for a week. For one week, I didn't worry about where I was sleeping. I ate healthy and even put on a pound or two. For one week, I cherished the unparalleled warmth of another human body pressed in close to mine. Liz and I talked a lot about a lot. She agreed to meet me in Colorado after packing up the apartment in Madison. After seeing me through some of Colorado, she would continue on to San Francisco. What would happen to us there, neither of us really knew, but we seemed to be moving in a positive direction.

After I had finished my second burger, the owner of The Refuge called me over to the bar to ask what I was up to. I told him I was running across the country. He asked if I'd like to tell the other patrons about my experience and I told him that I'd love to. He quieted everybody down, turned the jukebox off, and we sat, talked, and laughed.

"Well, where you staying tonight, bud?" I told him that I didn't know, but on my map it appeared as though the town park was nearby. "I'm sure I'll find a place," I said. The owner got on the phone and moments later informed me that he got me a room at the motel in town. And my dinner. And breakfast.

I was grateful for the hotel. Though I hadn't planned on being treated to a hotel room that night, it was admittedly part of my meager budget, and by that point, sixteen hundred miles into the run, I had my hotel routine dialed. I bought a couple more beers at the gas station and made my way in to room 107.

Once in the room, my routine was always the same: Lock the door, take off all of my clothes, and draw a steaming hot bath. I soaked with a beer and some chips, and from my spot in the tub, I tried to watch a throwback Hollywood film or a familiar sitcom. The Ritz Carlton couldn't have been any more luxurious as far as I was concerned.

When I was through soaking and shedding a layer of road, sweat, and filth from my body, I gathered the sad wad of dirty clothes I'd collected since my last motel. Which is to say, my shirt, two pairs of socks, my shorts, and my single pair of underwear. We took a bath together, and by the end, even I was a little

disgusted at the appalling condition of the bath water. I showered. I rinsed the clothes, hung them to dry, and drank my other beer.

I walked around naked. I emptied my pack, recharged my batteries, changed my camera's memory cards, recorded and took note of miles run and miles to go, and planned the next few days. I took out my sleeping bag, sleeping pad, and Tyvek tarp and hung them over lights and the cheap and ugly paintings on the wall and the desk. I took inventory of the little bit of food I was carrying (mostly sugar) and set to work on repairing tears and weaknesses on my shirt, shorts, and pack with a large gauge needle and a roll of dental floss.

I caught up on the news to an extent but switched back to *Sister Act*. I would fall asleep with the TV on and wake up later than normal, but it helped make me feel human. A little bit more human. I thought about the true ascetics: Peace Pilgrim, Gandhi, Jesus, the Yamabushi, Forrest Gump; I thought about them and wondered if they ever got a hotel room. If they spent their alms on a Motel 6 and a six-pack of beer.

There in Stafford, Kansas, I lay in bed with a good buzz and thought about people on horseback. People in covered wagons. I thought about the Santa Fe Trail that ran beneath my feet and connected America to Spain. To cross any distance on foot is to allow oneself an historical experience. Though this thought had occurred to me at other points in my journey, it didn't quite feel as real as it did going across the plains.

I awoke the next morning and took advantage of my free breakfast, opting for the bacon, OJ, and several coffee refills. I wasn't eager to get back to the numbers game on the road. Anyone who has done long miles day after day, on foot, wheels, or water, knows the number games that can start playing around in one's head—30 miles to Dodge at 4 miles per hour . . . 35 miles per day to the state line . . . 1,562 miles to San Francisco—and nowhere brings that out more than the Great Plains, where your mind can't take refuge in what might be around the next bend.

While running across the Great Plains, the days seemed to merge together. Small town after small town went by. A grain silo would appear fifteen miles off in the distance. And then ten miles, then five, then two, and then one until the silo would tower high overhead, and far off in the distance another grain silo would appear.

On the seventy-eighth day of my journey, at the edge of Fowler, Colorado, where the yard sales end and the alfalfa begins, the ranchers and farmers paused from their weekend gossip to witness a red-bearded man in short shorts and a backpack screaming, jumping, laughing, crying. Pointing at the mountains far off in the distance, I knew I was becoming unhinged, and that the sight of home was doing it.

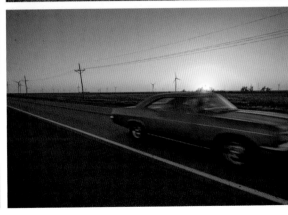

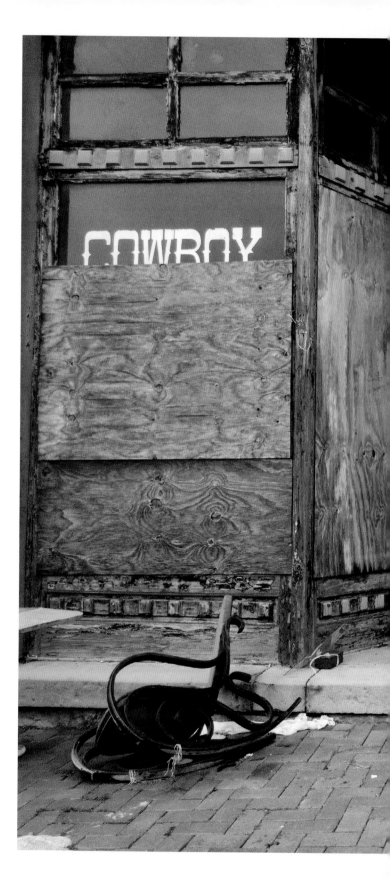

Ralston, Oklahoma

I was standing outside the largest building in Ralston taking a photo of the facade when Sean pulled up and asked if I wanted to check out the inside. He brought me around back and up the stairs to a second story theater—long ago left to the wear of the elements. The curtains boasted adverts of thriving businesses long ago gone. Sean and his buddy were trying to bring it back to life. The Osage Reservation has a dark and bloody history of oil boom and bust, foul play, cattle, drugs, and murder. There in Ralston, it was visceral.

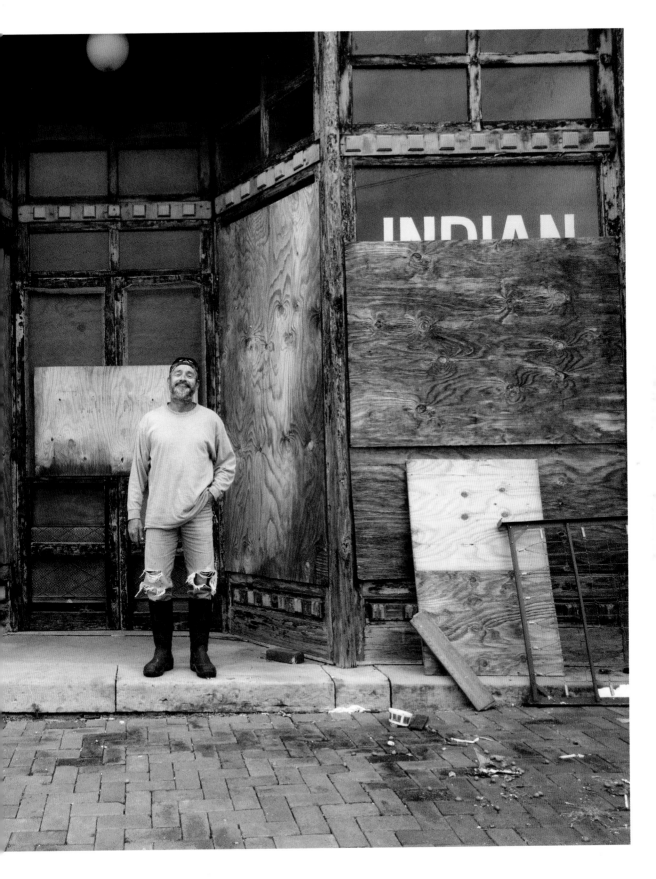

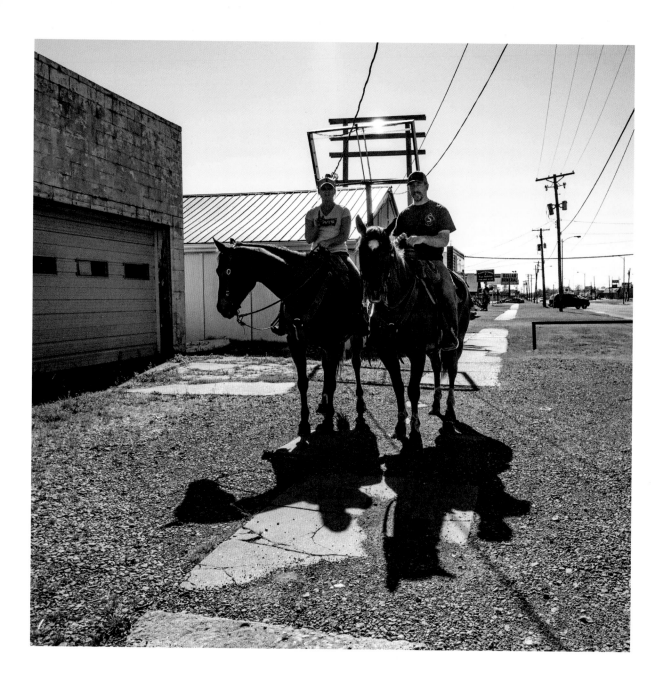

DAY 52 ◆ MILE 1,362

Wagoner, Oklahoma

"How far you guys goin'?"

"We just came in to town to drop off
our Redbox rentals."

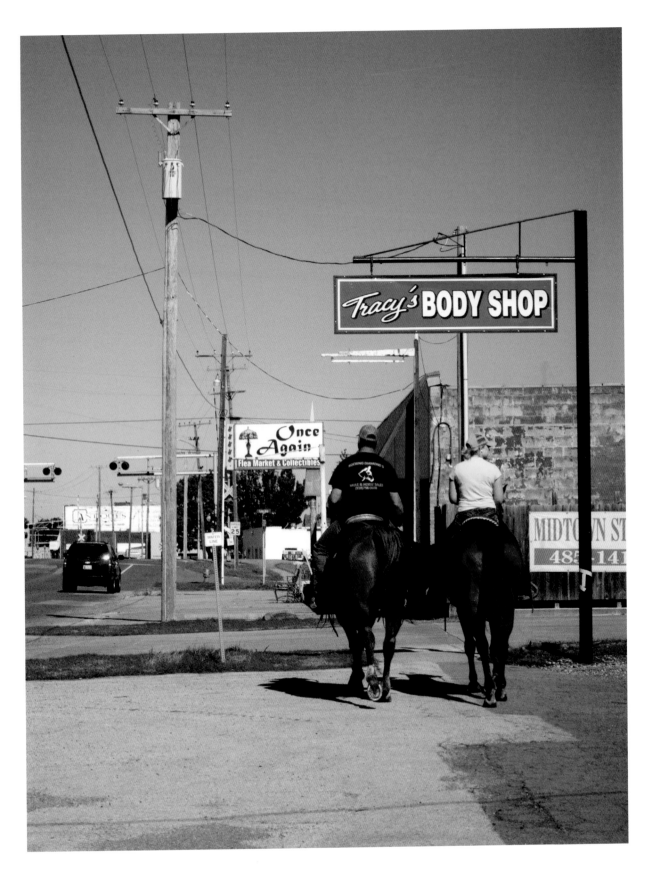

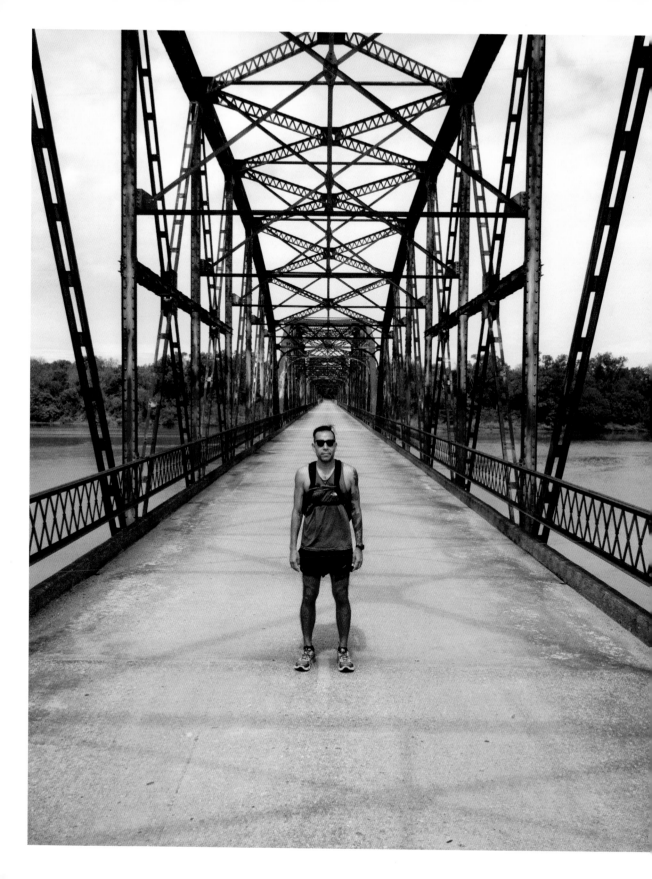

Osage Nation, Oklahoma

"What are you?" one guy asked. "You have some Indian blood in you. You're . . . ?" another guy said.

Yatica Fields seems to get the question enough that it doesn't bother him, and he's quick with a good answer and prepared for more questions. Yatica joined up with me in Osage Nation where his Cherokee, Osage, and Creek ancestors had been relocated from Missouri, Georgia, the Carolinas, and elsewhere. He grew up on these lands. When he contacted me saying he'd like to join me on my run for a couple days, I agreed immediately. To get to know a land through a man who carries the blood, the history, the fight, and the honor of so many people was, to me, history incarnate.

McCord, Oklahoma

Richard called me over to his car and then had me wait several minutes while he finished a call on the phone. He pointed to the hill across the way: "You know what that hill is called?"

I told him I didn't.

"It's called (something or other's) nipple. Also a burial ground for the Osage."

I looked over at Yatika and he gestured in a way that said he knew that already.

"You guys look like you're doing the Fly Boy Shuffle. You know what that is?"

I told him I didn't. He went on about being in the army and how you can shuffle along forever once you're used to it.

"We call that the ultra—" but he cut me off to tell me about the oil refineries in Ponca City, and why the buffalo didn't go extinct in the plains while the horse and mammoth did, and Italian camouflage. I yawned, and he said "I'm sorry, am I boring you?" He went on about the Osage and the oil boom and about the broken piece on his pickup. I started shivering.

"You know why you're shivering?"

I told him I had a pretty good idea. But he went on to explain to me that it's because I'm not wearing enough clothes and I should be moving. Despite this knowledge, he did not let me keep moving.

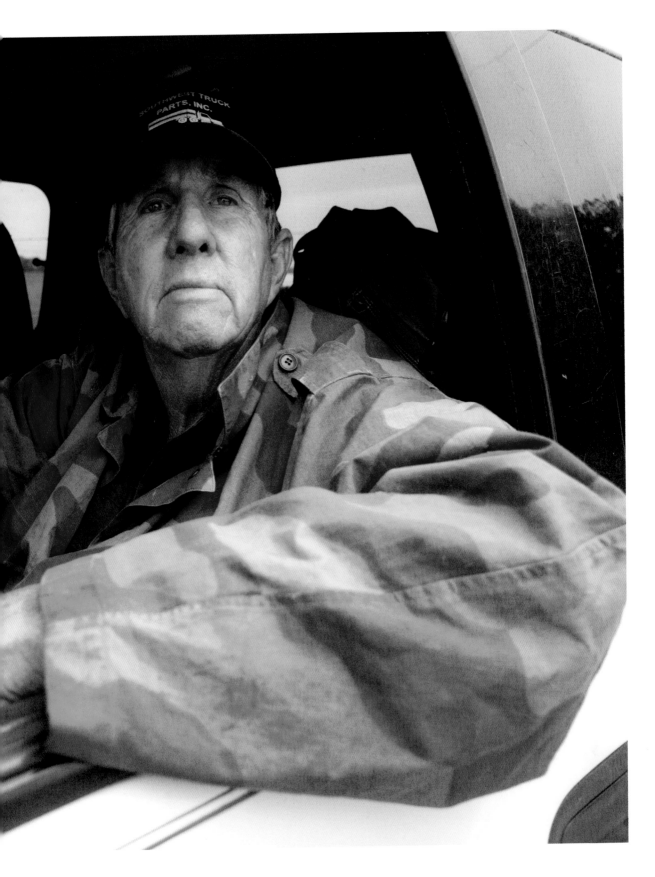

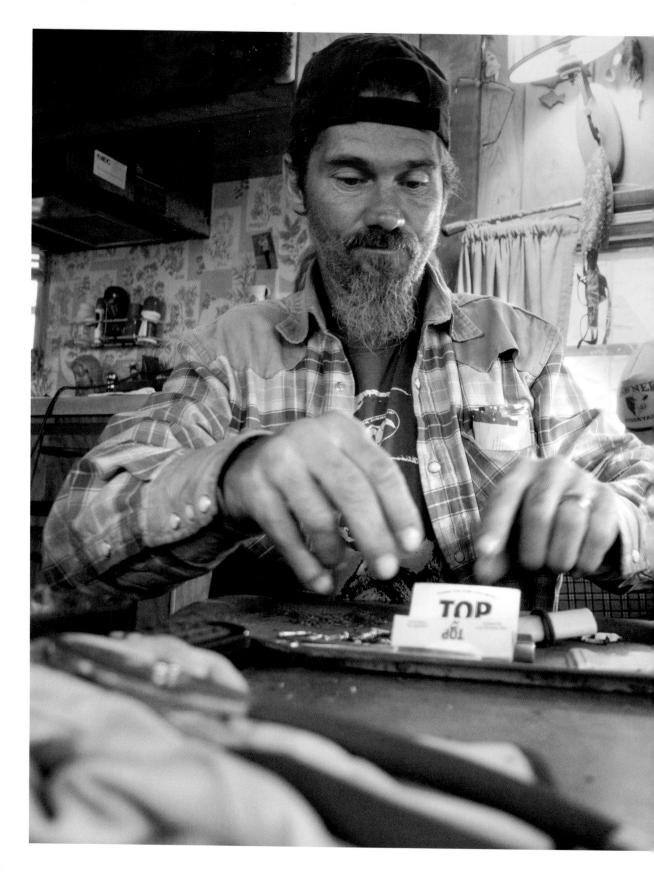

Ralston, Oklahoma

"Where you stayin', brother man?"

I told him I wasn't sure.

"You're staying with me then, brother man. I got an empty house. I live in the trailer next to it. Nobody in the house but two dogs and a crazy fucking squirrel. You're not gonna steal nothin' are you?"

I told him I wouldn't.

"Good. So long as you don't steal nothin' and don't go into my brother's room. It's his place. But he's livin' down in Tent City in Tulsa. I just feed his dogs and pay the electric bill."

Kevin talked a mile a minute into the evening about everything from prison to getting his arm crushed by a bull ("1,890 pounds, brother man") to hitching up to Nashville to winning free Clint Black tickets to his two daughters. He slowed down a bit when he brought up his mom who passed while he was in prison. Walked across the RV and grabbed the flower vase that he had turned into a makeshift urn. He told me how she appeared before him one night.

"'It's just me,' she said."

He poured some ashes into his hand, some into mine. We went out in the yard and spread her among the grass and the rabbits and the pit bull tied up. He geared down and a calmness came over him.

In the morning, he said, "South Carolina? That's a long way, brother man. You stay as long as you need to rest up. That's a long way. I know. I've hitched it."

DAY 56 ◆ MILE 1,458

Ralston, Oklahoma

Eugene Allyn pulled up and shut off the engine of his tractor. "There's a bridge around the corner. You know the movie *Twister*? Well that bridge is in the opening scene. And three months ago, they filmed a scene here for this movie *Starbright* or *Starlight*. A chase scene. Two cars, side by side, going sixty across that bridge. They started filming at five in the evening. Shot straight through till three in the morning. I stayed up and watched the whole thing. Flipped a car on the opposite side. I didn't get to see no movie stars though. They were just stunt men."

Lakin, Kansas

"You got a Scamp and a boat. I'd call it a Scoat."

"You can call it what you want," Hal told me. "I call it a 2014 Self Made." His face was tanned deep from a winter or more in Arizona. I asked if it leaked.

"A little bit here and there. Nothing like when we left New York. Pieces were falling off. It leaked. I didn't fucking care. We just had to get the fuck out of New York."

Hal and Genie were headed back to New York. Very slowly.

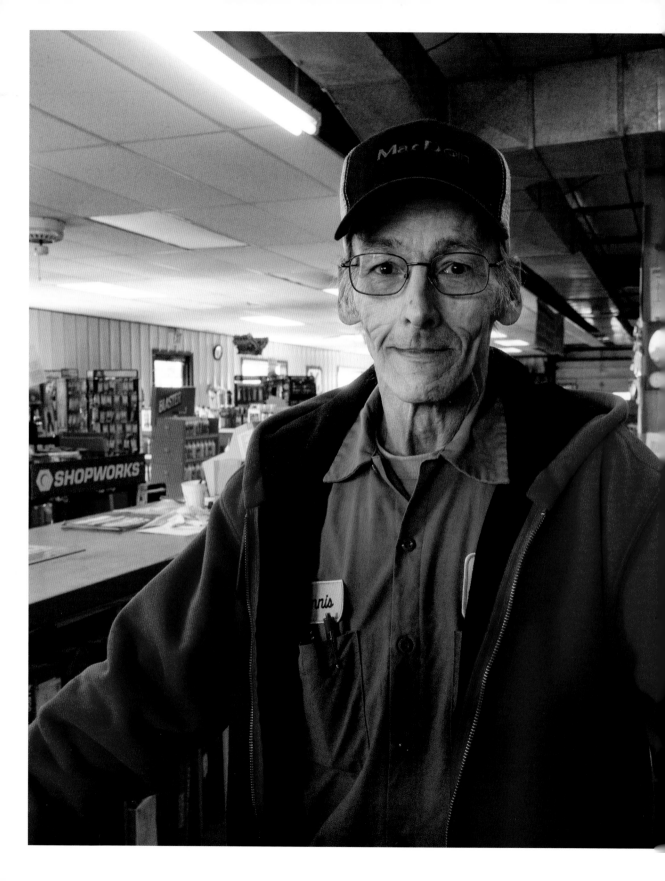

Mount Hope, Kansas

I ducked into the Napa off K-96 to get out of the wind for a moment. They offered me a cup of coffee—Folgers, no cream, no sugar, no creamer. We got to talking about my trip when Dennis told me he'd walked from Harrison to Silver Dollar, Missouri, when he was a boy.

"Why?" I asked.

"I run away."

He walked away and returned a few minutes later to tell me about the boys' school his parents had put him in. And about one of the teachers who had done unforgivable things to one of the boys.

"One day when we were loading on to the bus, I kept walking past the line. A few other boys seen me walkin' and caught up and asked if they could join. When we got to Silver Dollar we were pretty done. We didn't have nothin' to eat but what we found alongside the road. We called up the school to come get us. They said, 'You found your way up there, you can find your way back.' So, we turned ourselves in to the police. I'll tell you, staying at the police station was nicer than the boys' school. It cured my desire for walkin'." He laughed, revealing a void of teeth.

I looked up the two towns. They're over two hundred miles apart.

DAY 73 ◆ MILE 1,757

Cimarron, Kansas

Cesar bought this place from the previous owners ten years ago.

"Before I worked in the fields," he said, as he pulled the final old fashioned from the case. "Now I'm inside. When it's cold outside, I'm inside. When it's snowing or hot outside, I'm inside. When it's raining outside, I'm inside. This is much better."

DAYLIGHT DONUTS

DISPOSABLE GLOVES

DAYLIGHT
Long John's

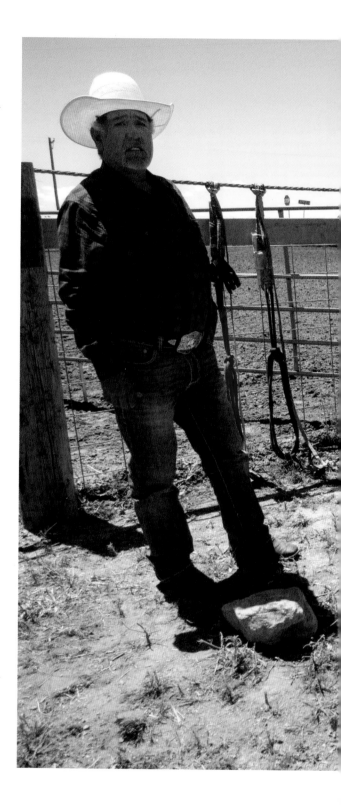

DAY 80 ◆ MILE 1,974

Avondale, Colorado

I noticed a rodeo taking place alongside Highway 50 outside Avondale, so I stopped in to see what I'd find. This is Canyon and Ryder—buds from Alabama, competing as Junior Bull Riders. Three rodeos in three days before heading back to Alabama. Over a quick conversation, they made me realize how much I loved the kindness and hospitality that I experienced across the South.

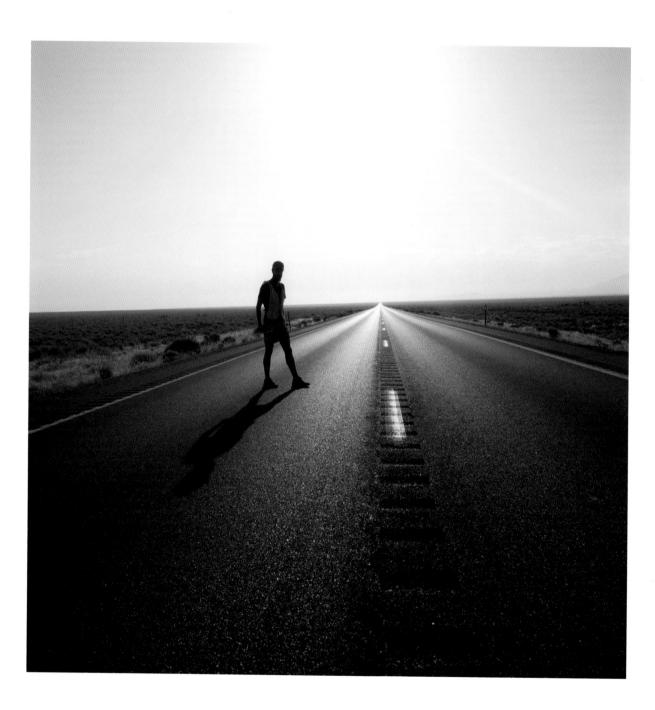

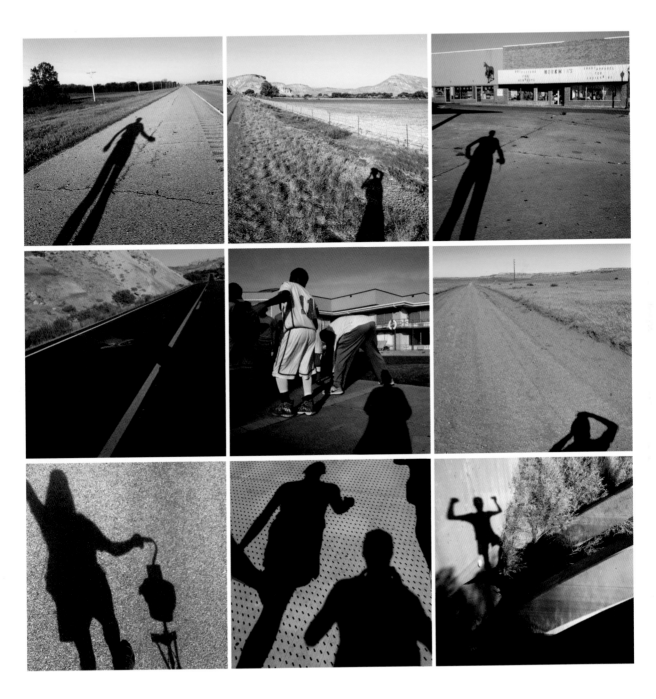

165

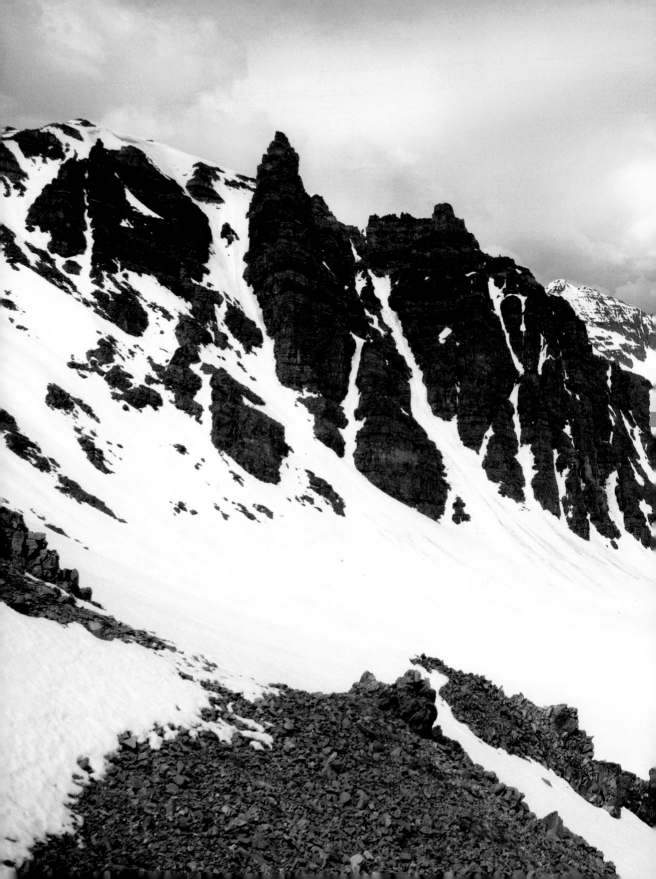

THE ROCKY MOUNTAINS

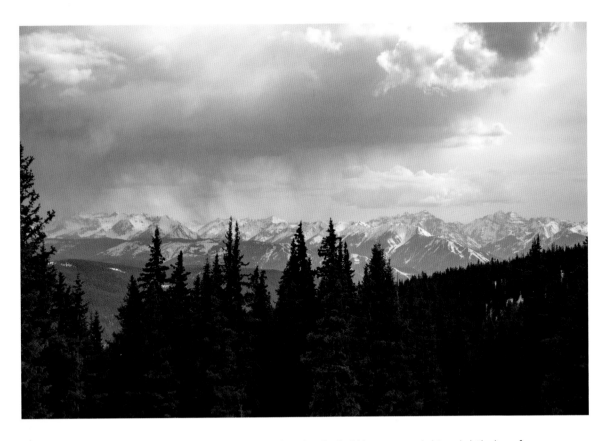

DAYS 80-99 ◆ **378 MILES** I arrived at the Jackal Hut on my eighty-eighth day of running. Smoke rose from the chimney, which meant that Liz was there and I could stop worrying if she'd made it to the hut. Though nearly June, the hut was still enveloped by snow on account of it sitting on a mountaintop at nearly twelve thousand feet, and several late-spring storms that had come through.

I had been in the Rockies for over a week and within sight of them for nearly two. Being in familiar territory meant I was able to set aside my map and put my guard down some.

Just outside of Denver, I picked up the Colorado Trail, a five-hundred-mile thru-hiking trail along many of the state's most precious gems. I rose up from the Front Range out of Waterton Canyon, where the old crumbling granite makes its way downward in the direction of gravity. Far off to the south, Pikes Peak rose prominently above its surroundings, snow-covered and majestic. The streams swelled with the warming temperatures.

Liz had been leapfrogging along with me for the past several days—joining me for several miles out on the trail, then returning to her car and jumping ahead to meet me at the next road crossing or town.

We were enjoying each other's company. We were enjoying the thrill of being in nature, of moving, migrating, and savoring this simple movement westward. We were enjoying the simplicity of this life even if it was temporary. Most of all we were enjoying not having broken hearts. We made a bed directly in front of the fireplace, ate a simple meal there, made love, and slept through till morning.

I left the Colorado Trail to pick up a series of trails that I helped maintain two decades earlier as a backcountry hut keeper with the 10th Mountain Hut Division. Both modern and clean, the huts allow for consistent travel across the Rockies. Whimsically named for donors or people who passed away, the huts are a welcome sight when hardly a sign of civilization is seen for a half a day or more. Twenty years ago, for eight bucks an hour, I cleared trails, chopped wood, and painted the propane tank to perfection (I'm fine with mediocracy, but my boss was not). In the winter, I skied to the huts to sweep the floors, bust the cone (don't ask), and haul out any food (and booze) the guests may have left.

I moved on to Uncle Bud's hut the next day and Betty Bear hut the day after that. I stopped taking notes and snapped a photo only here and there. Being home didn't feel like a place to observe, but rather a place to simply exist and to know without thinking.

At the Margy's hut, only fifteen miles from home, a spirited group of friends gathered to welcome me home-ish. In jeans and fancy leather shoes, my brother marched six miles through the snow to join the welcoming committee. Everybody around me was filled with happiness; I was too. But I was prevented from enjoying this homecoming moment in its entirety knowing that after this I would continue on into the vast open desert.

Into town, the newly budding aspens waved down at us. The melting spring snow filled the streams to their brinks. The snow would soon be gone and the monsoons would follow. The chanterelles would come out in August, the boletus a little before. If I was going to find any morels, it was going to be then and there.

I stayed at my mom's for three or four days. It felt entirely too comfortable and I knew that no amount of time would satiate me; and the longer I stayed, the more daunting the desert became. I half wondered if maybe I should have gone north or south to avoid home.

I left Aspen on the ninety-seventh day of my journey, making my way south-west over the Elk Mountains and on to the Western Slope.

The desert was upon me almost immediately.

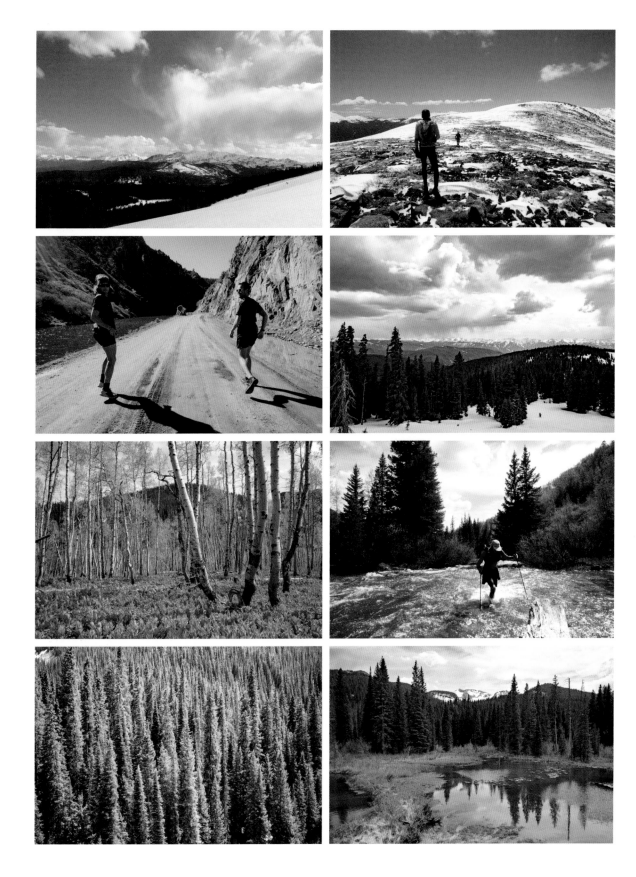

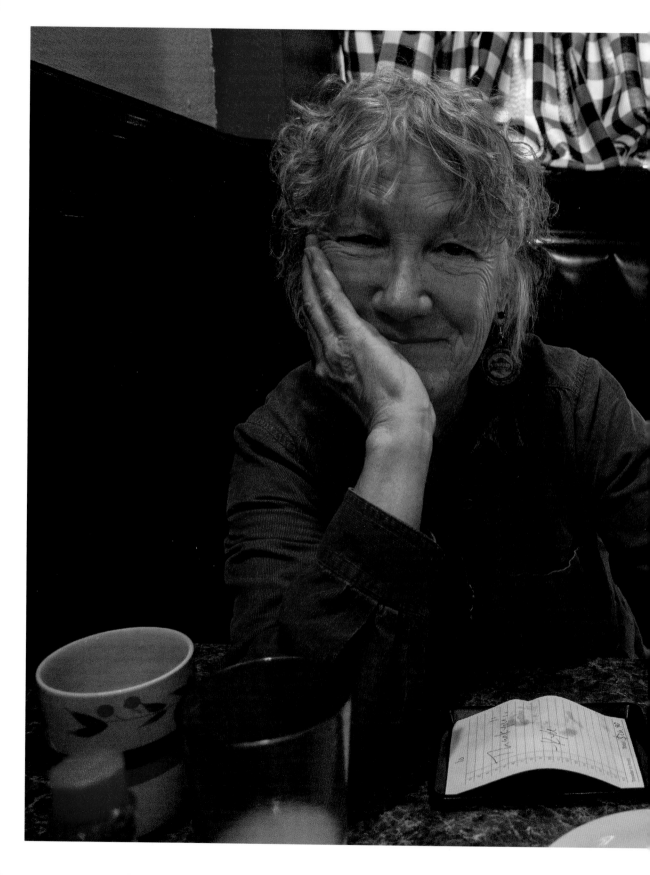

Colorado Springs, Colorado

"You know I don't like this." My mom was embarrassed by me taking her picture. (Multiply that embarrassment by a thousand and that's the level that I felt for much of my life by this person who will ever remain unrestrained by the mores of our time and culture.) "I like this napkin," she says, as she's figuring out how to sneak it in her purse. It's black-and-white checkered fabric and I have to admit it would look pretty nice in her kitchen.

"Please don't steal the napkin, Mom."

She doesn't, but after we left B Street, I kind of wish she had.

We walk around downtown for a little bit on this mini-type of vacation that she has provided me from my TransCon. Treating me to dinner, breakfast, and lunch. Beers and more beers. Asking me about the people that I've met—the weirdos, the homeless. Reliving a few of her own moments that were no less inspired and continue to be so.

Mom turned seventy last month. Next month she'll retire. Current plan is to drive her Honda Element (with pop-top) to all four hundred of America's national parks. She just discovered Guy Fieri's book on American diners. So why not throw that into the trip as well. Thanks for visiting, Mom. Embarrass me forever.

DAY 90 ◆ MILE 2,203

Tennessee Pass, Colorado

"Are you a professional ice carver?" I asked Les, based on the sweatshirt he wore proclaiming as much.

"Do I look like a professional anything?" he replied in a thick Long Island accent, made even thicker by our unlikely surroundings. He palmed his belly. "I'm a professional at eating and lying down."

He and Shelly celebrated their fiftieth wedding anniversary yesterday. "Twenty-three of the best years of my life," he said. They both laughed.

I gave them rights to refusal on the portrait. Les checked it out. "We're handsome. Shelly look at us. We look good."

She looked at the picture on my camera. "We look good," Shelly agreed.

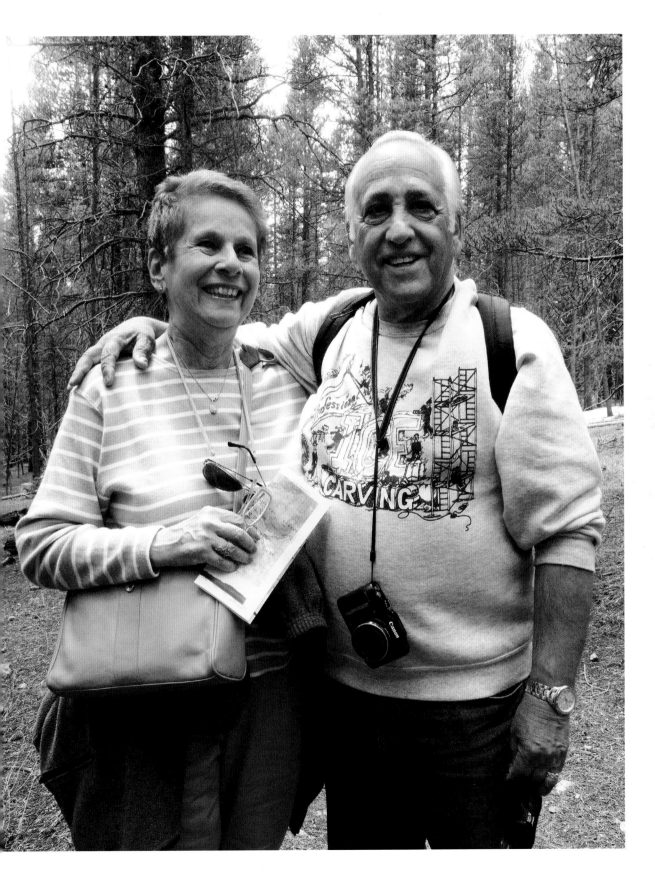

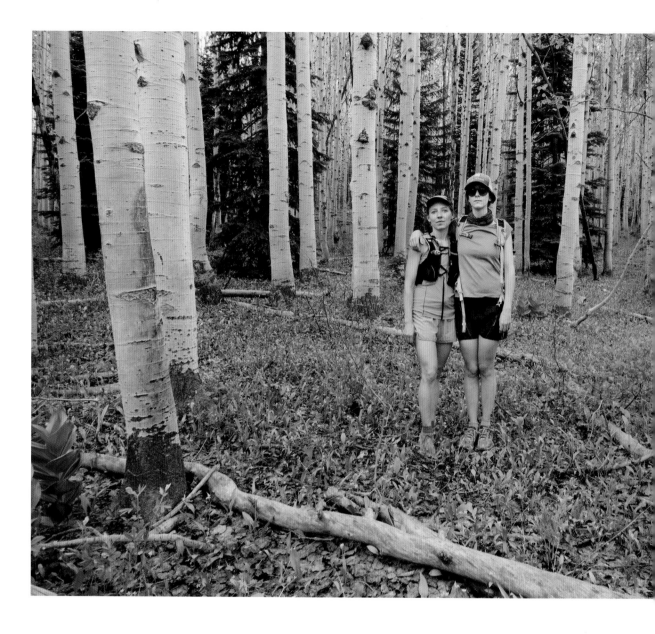

DAY 99 ◆ MILE 2,314

Kebler Pass, Colorado

These two just ran farther than they've ever run before. Rounded to the nearest marathon, they covered 26.2 miles down Kebler Pass, along the North Fork of the Gunnison River, and into downtown Paonia in time for ice cream scoops.

When the miles started to wear, Liz requested a story for distraction, and I said this is when you focus on where you are and how you're feeling. She flipped me off and kept running, which was the only proper response.

Kebler Pass, Colorado

Helena is digging a sixteen-passenger
van out of the concrete slush with nothing
but a sturdy plastic plate. I asked if I
could help and she insisted she'd be fine.
I asked again and she said she could do it.
She had time and just needed to keep
digging. I pushed again, asking if I could
at least dig for a few minutes to give her
some rest and finally she relented. We
proceeded to get the car more stuck. But
with the help of a passing pickup, we
eventually pulled it out of the concrete
spring slush.

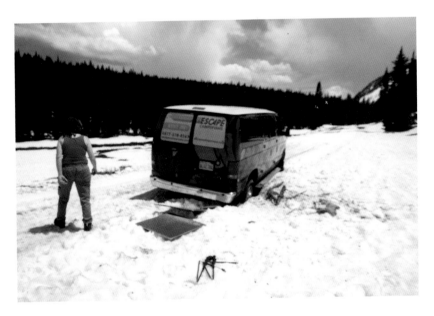

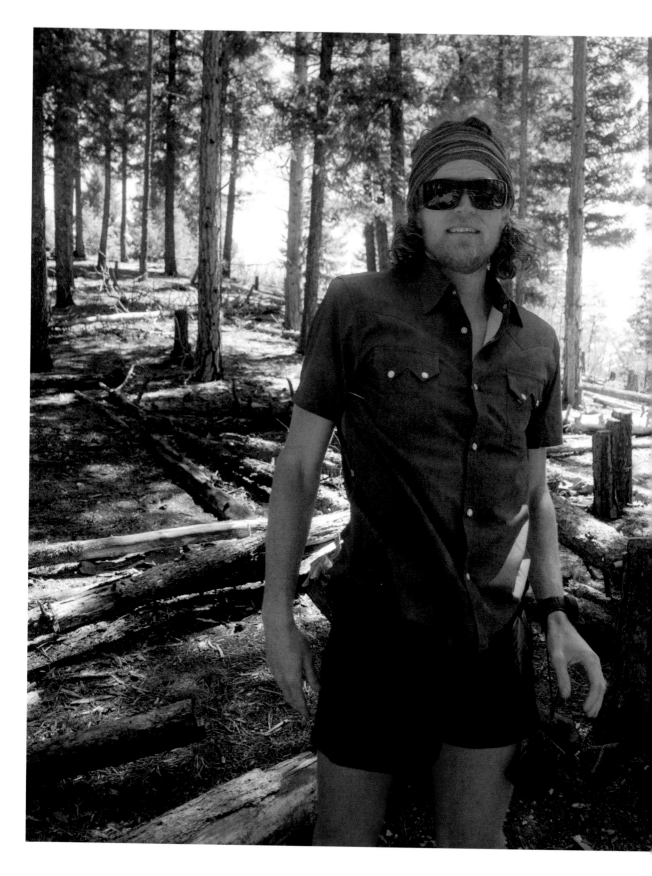

Waterton Canyon, Colorado

Joe met me at a burger joint in the evening before I set off on the Colorado Trail in the morning.

"Man, you stink," he said. "You're rotting."

He smiled while he said it. It was a nostalgic sort of smell for him. One that is produced by alcoholics, diabetics, and a few others who either voluntarily or involuntarily push their body to such an extreme that it essentially begins to consume itself. No stranger to extreme missions, he took it in and reflected on his own deep efforts.

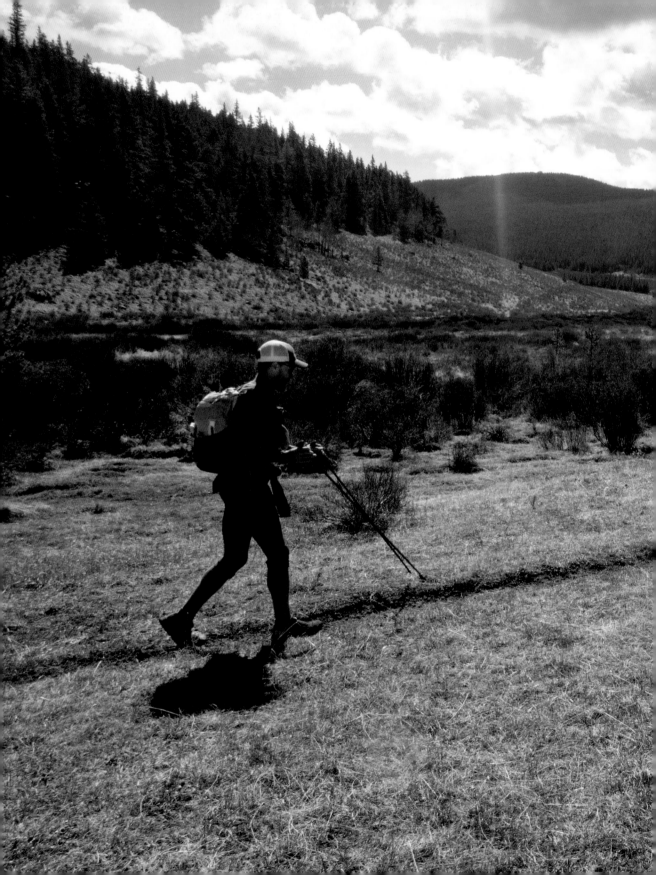

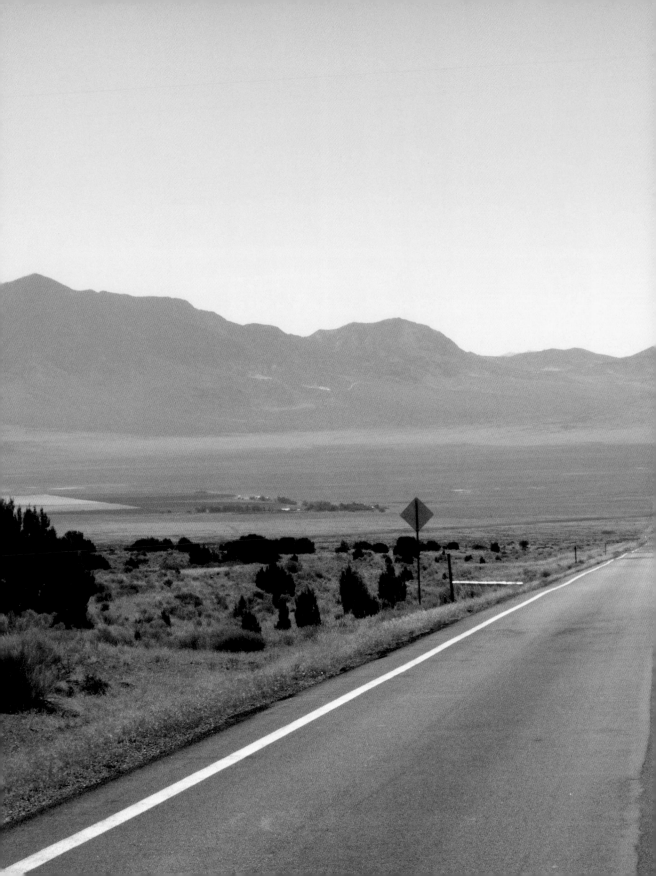

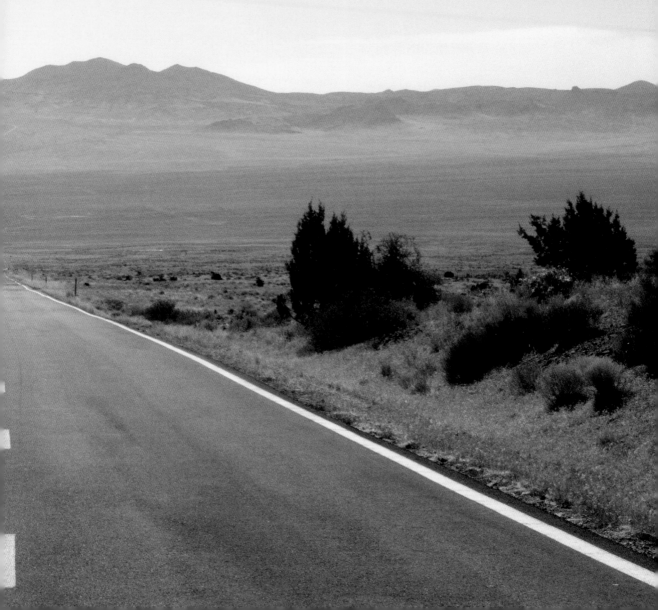

THE DESERT

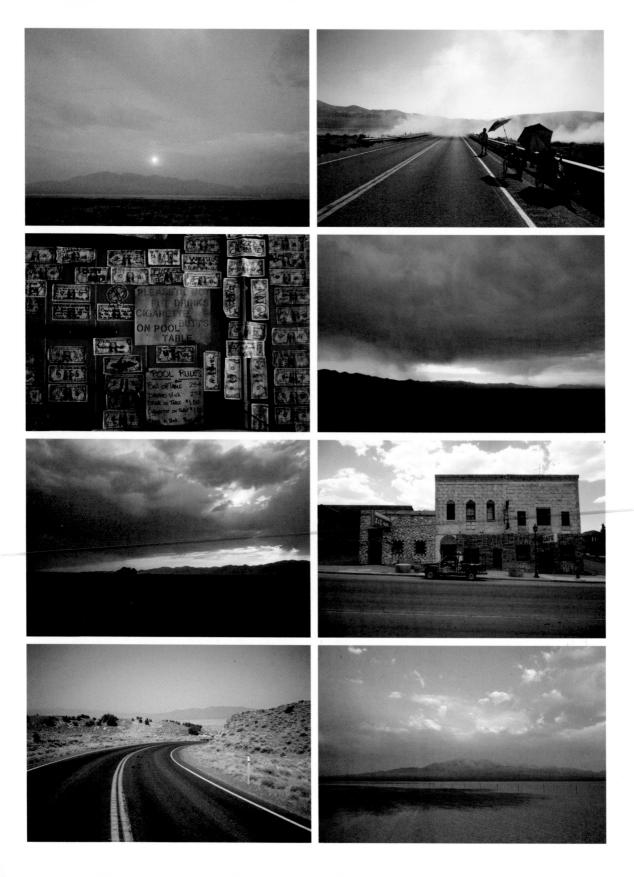

A hot gust of wind blew through the concrete underpass, carrying with it stinging grains of sand, dead bugs, and the faint, stale perfume of desert sage from the sea of sun-bleached green just beyond. A bird had been singing earlier, but it flew off to find its own shaded protection from the afternoon scorch. The slow crescendo of an approaching eighteen-wheeler was somehow musical—or if not musical, calming and soothing: the rumble of the engine, the whine of treaded rubber on pavement, the parting hiss of the air—all softened by the fifteen feet of concrete, asphalt, and earth separating me from the scorched earth above.

It gave me comfort to know that there was another human being out here sharing the loneliness of the desert with me.

It would be a stretch to say that it was cool in my culvert there below Highway 50 in Nevada, but compared to the 107 degrees just beyond, the afternoon shade I had found in it was a veritable icebox. Beside me was my red three-wheeled baby jogger that carried my supplies. Sitting on the ground was a Lowes five-gallon bucket carrying some of the three gallons of water I had become accustomed to packing, as well as some of the comforts provided by the ease of ball bearings, rubber wheels, and smooth pavement—Pop-Tarts, Coke, American flags I had found by the side of the road, and a CB radio that had been tossed out of a trucker's window, which provided me with a medium to talk into the void. The Horse with No Name, as I had dubbed the stroller, had been with me since Hanksville, Utah, and would remain with me until I reached the Sierra Nevadas, out of the desert heat.

Having been on the move for nearly four months, I was having one of those days (they seemed to be coming more often) where I was feeling particularly feral—a sentiment often accompanied by a lost sense of self, intense chocolate milk cravings, and a roadside analysis of Nietzsche.

"If you stare into the abyss," the great philosopher proclaimed, "the abyss stares back at you."

Consumed by a sudden urge to pee, I rose from the concrete floor and wondered what color pee it would be. My body ached—as it has from the moment I turned my back on the Atlantic Ocean.

I said, "please, please, please," and thought, yellow, yellow, yellow, but things had not improved since that morning, and my urine again came out sludgy and red. Either I didn't have the energy to panic or this had yet to trigger a primordial alarm. I texted my symptoms to a close childhood friend whose path led him to being a doctor, complete with wife, house, and kids.

"Beets, bladder infection, or STD. Hopefully not a stone or something called rhabdomyolysis," he texted back. "Probably the rhabdo—muscle breakdown from dehydration and too much running. Drink shit-ton of water."

Before setting my phone aside, I reversed the camera and looked at a face with sunken cheeks, hollow eyes, and an empty gaze.

Oftentimes, we don't have the capacity to recognize our own personal growth or decomposition—it's a realization that's reserved for reunions, weddings, and funerals. Occasionally, though, it's drastic. The flu, followed by dehydration, long miles, and rising temperatures, chiseled away at the last of my fat and into my muscle. In a culvert, beneath the Loneliest Road in America, the abyss was staring back at me.

Hours later, I awoke from a nap and wondered for a moment, as I was doing often these days, where I was and what I was doing. Looking around at the austere walls, uninterrupted views, fresh air, and passive cooling, I imagined the greatest postmodern accommodation of our time. I pictured it in one of those minimalistic magazines like *Dwell* or *Wallpaper*: I contemplated Airbnb, but for culverts.

The sun softened and the heat abated. The temperature would dip back in the double digits not long after sunset.

Before rising, I thought about the thirteen-mile straightaways, and the three hundred miles of desert still left to go. I thought about my dinner of Slim Jims and Pop-Tarts. And finally, I remembered a line from a book I'd read not long ago by an author I couldn't recall: "I can stand this—right now—at the present moment, very well; I will do so and will refuse to look forward even five minutes to what I may have to stand."

There is an overlooked monotony present in most great adventures. In undertaking a journey that I had hoped could be approached by the "every-man," I had neglected to realize the change that occurs as a result of that monotony. I only became aware of the change by the evolution of reactions I received inside gas stations.

I packed away the packaged donuts, warm Coke, Slim Jims, and water. I situated things into the five-gallon bucket and the bucket into the jogger. As I climbed out of the culvert and onto the highway, the chirping of crickets and symphony of birds increased and the pastel hues of the sunset grew more intense.

I was hoping to match my twenty miles from that morning.

The stars began to appear, and then the Milky Way, and then one, two, three shooting stars. In the darkness, it was nearly impossible to see the far end of that maddening stretch of road, so instead I focused on the few faint feet that I could see just ahead of me.

I stopped to pee. The blood was gone. Or at least, in the dark, appeared to be.

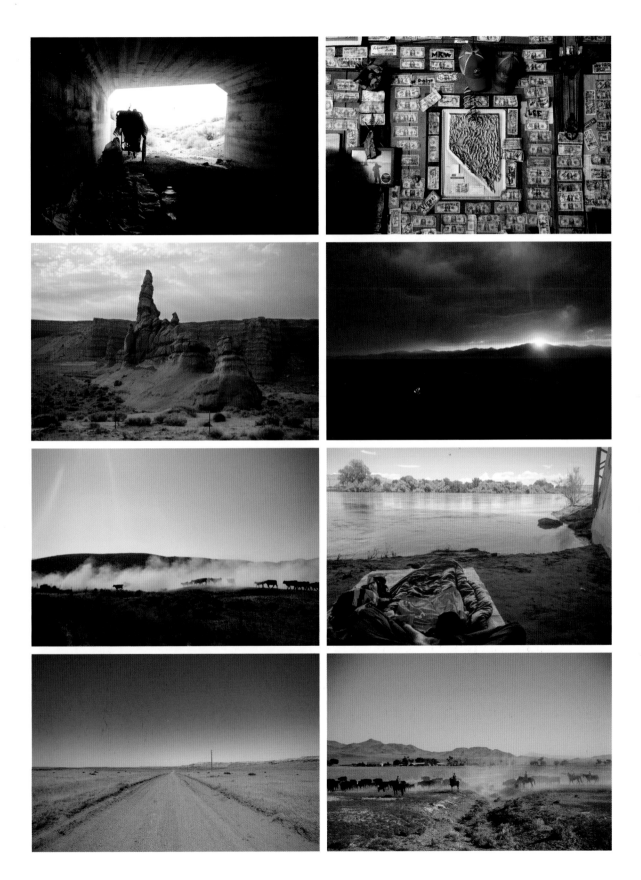

Moab, Utah

"My son wrecked a jet boat there."
Timmy pointed off into the river. He
was coming down from Castle Valley
where a different son had wrecked a
pickup truck. We got to talking about
luck and motorcycles as he drove me
back to where I'd left off a couple days
earlier. "I like to ride, but I don't have
one now—wrecked my last one."

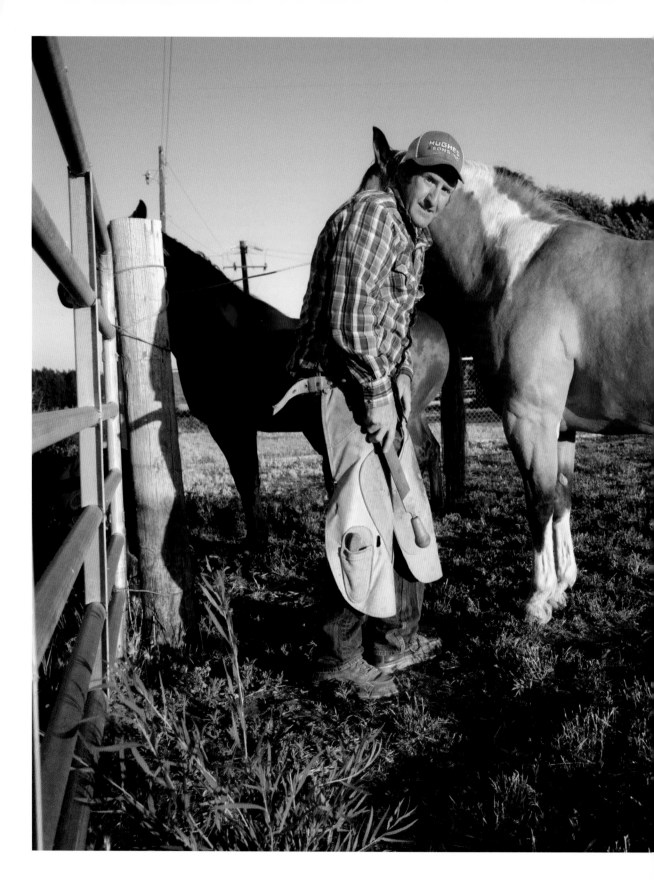

DAY 118 ◆ MILE 2,759

Greenville, Utah

"How often do you get kicked?"

"More often than I should for as long as I been doing this," Russell said.

Russell travels about the area shoeing horses. Rides them occasionally.

"You're headed to the 50?" he asked.

I told him I was. And prepared for the lecture on it being the Loneliest Highway, a desolate and barren wasteland, and make sure you have plenty of water sort of thing.

"That's beautiful country out there," he said. "I sometimes head out there for work."

"Well, keep an eye out for me."

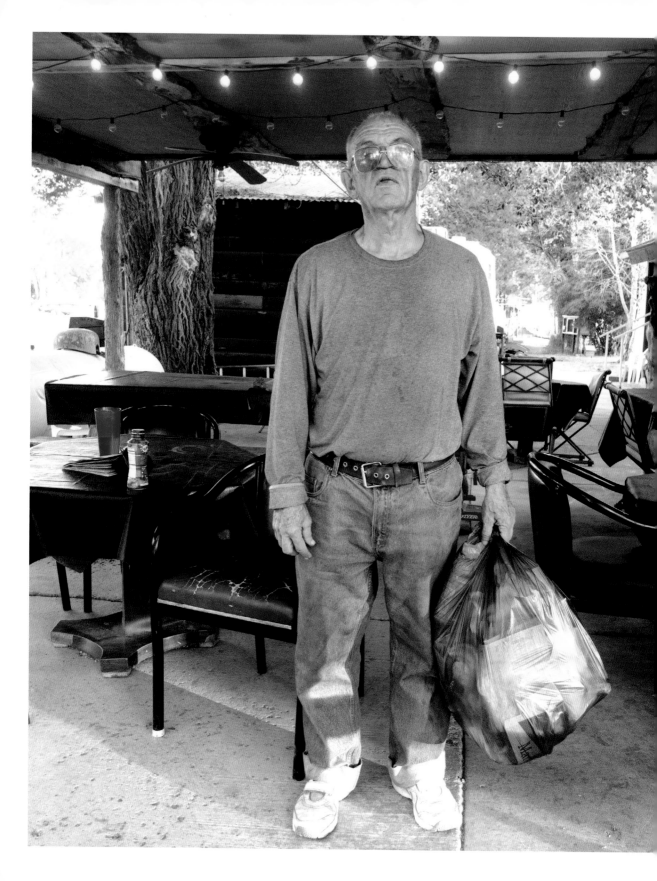

Antimony, Utah

"The Second Coming is approaching," Jerry said. "Next twenty years, I imagine. Just look at the evidence."

Jerry held an ongoing conversation while cleaning the patio and bathrooms for the Antimony Merc. He told me about the three times he died, and about his Indian Chief, which he bought new and held on to for fifty-seven years before it caused one of his deaths and his wife made him sell it. He told me about the three motorcycle gangs he was a part of in Detroit back in the fifties and sixties—the Destroyers, the Violators, and I forget the third. He told me about the gas station he owned there and how he grossed 1.7 million in his first year. And he told me about the murder he witnessed in Detroit that urged him into his own witness protection program—that brought him here to Antimony, Utah.

"You're a liberal?" he asked me. I told him I swayed that way. "Well, that's fine. But you can't be a progressive, because I can tell you're not evil. Like that Nancy Pelosi. She's evil and she's trying to take this country down." He went on about Pelosi for quite some time, before asking where I got my news. I refrained from saying NPR. "You need to get it from Channel 257. On the dish. They're the only ones that incorporate the scripture into the news."

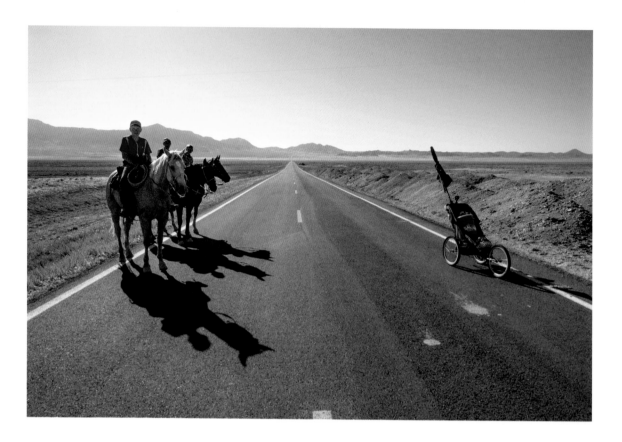

DAY 119 ◆ MILE 2,845

Milford, Utah

I had been approaching a small cattle drive from across the valley for over an hour. I could see the dust rise up from a calf escaping the herd, and the taller, slim figure of man on a horse circling around and bringing it back into the mix. By the time I'd arrived they had already crossed the highway and were making their way toward the holding pens. I was sad to not be able to talk to them, because out there in the Great Basin, conversation with anybody or anything, no matter how short or mundane, is a breath of humanity.

Three of the five riders came circling back around and clopped up onto the highway. They were Joe, Billy, and Emmet—twelve, ten, and eight— and as curious about me as I was about them. I told them what I was up to; "that's pretty cool," Joe said, with a half-smile that I think is a full smile for cowboys.

"How do you guys deal with the heat?" I asked.

"Go inside," said Billy.

"Crawl under the shed," said Emmet.

We'd have continued chatting, but there were cattle to herd and miles to run before the midday heat.

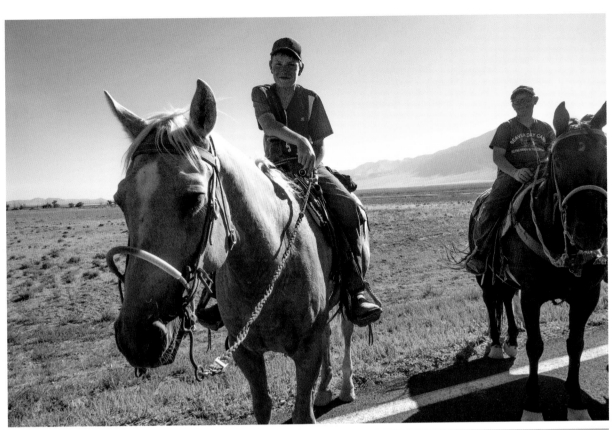

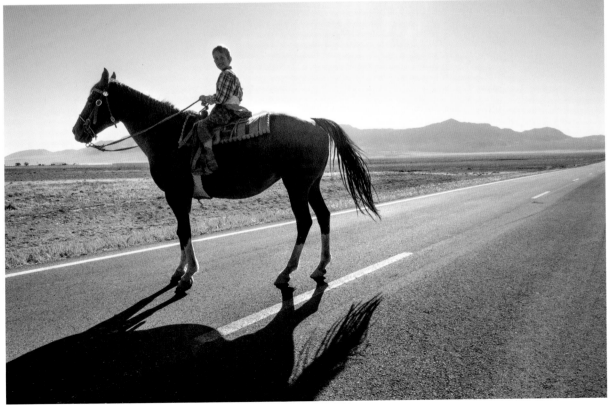

DAY 119 ◆ MILE 2,845

Garrison, Utah

A garbled phone call came through:
"Rickey! . . . run . . . me and . . . tomor-
row." I took it as wanting to run in the
near future. I texted where I might be
and that I'd be off the highway during
the heat of the day.

Maj from Australia and West from
New Zealand pulled up alongside me
as I started my evening. Game to do
some miles, I handed them the
controls to the baby jogger as we ran
into the night—one driving, the other
running, and me so grateful to be
running with both arms swinging. They
saw the beautiful glory of running
these desolate roads at night with stars
overhead and a crescent moon
illuminating the way. The following
morning and into the heat of the day,
they felt the oppressive heat and brain
bake that sends me in search of shelter.

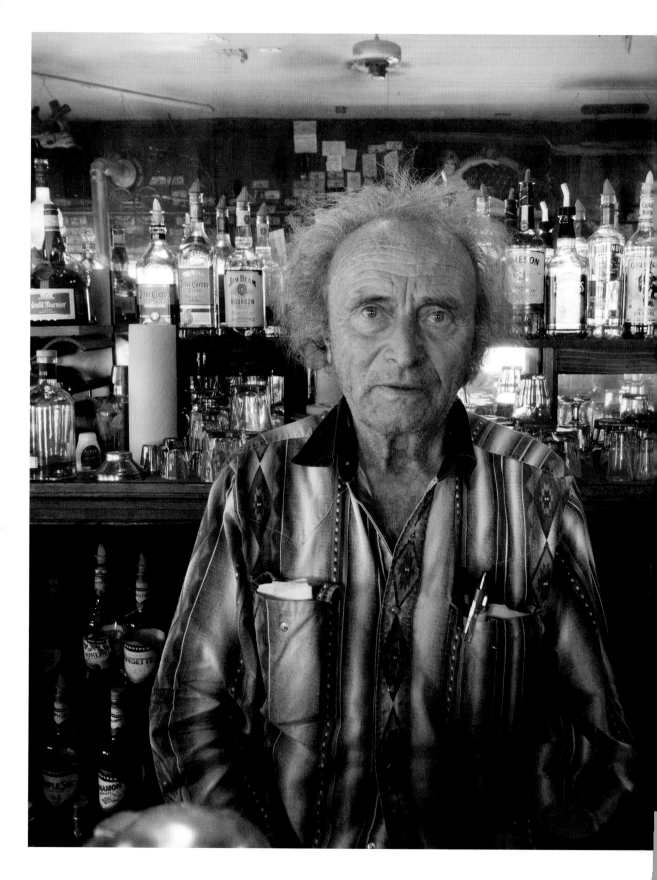

Austin, Nevada

"Commies and ni%@£?"

Victor was spouting out something of a rehearsed diatribe against most of the world's population.

"Who are the good guys?" I finally had to ask.

"Well, you and me."

To sway him from this very passionate tirade, I got him talking about killing bears in Siberia and beating Navy SEALs in Florida.

Long ago from Serbia, Victor's journey over the past forty years had taken him to Ohio and Florida, where he accumulated some grand stories and a plethora of prejudices.

A friend recommended I stop off at this bar where it is still simultaneously October 2016 and July 1907—one date touting the underdog, Donald Trump, while the other is sadly displaying a mining boom gone bust.

A *Newsweek* article on Highway 50 that I would later pick up says his theories of race relations "borrow equally from Sean Hannity and Adolf Hitler" and a flat-out suggestion to "stay away from the racist Serb."

Sometimes my biggest effort on this trip is to listen to Victor.

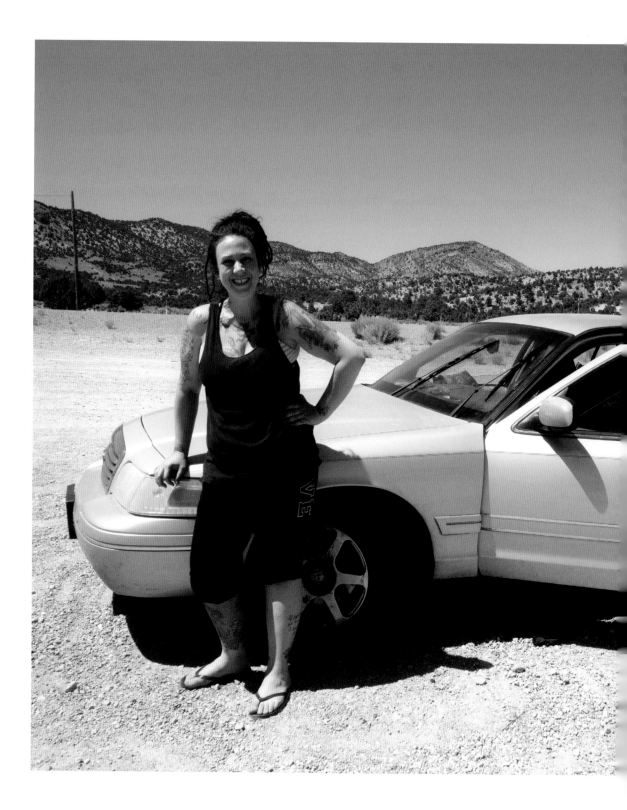

Major's Junction, Nevada

Kelsey flatted four days ago. She walked for six miles with her thumb out before getting picked up by the police and driven back to her car and warned that she's not allowed to hitchhike in these parts due to there being a prison. After two days, she finally made it to Ely, where it took two more days for her to organize a return with a new tire.

She tells me this story all while smiling and eager to get back on the road.

"Where you going?" I ask.

"I have no idea." She laughs and drives off.

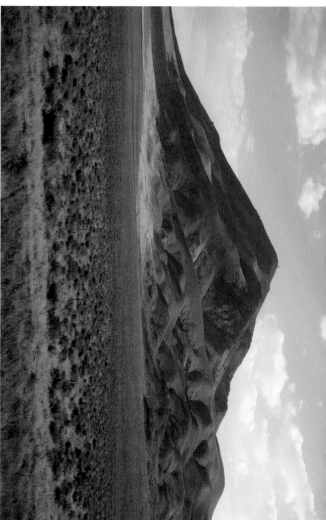

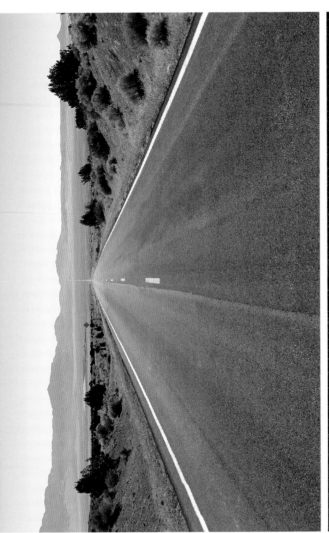

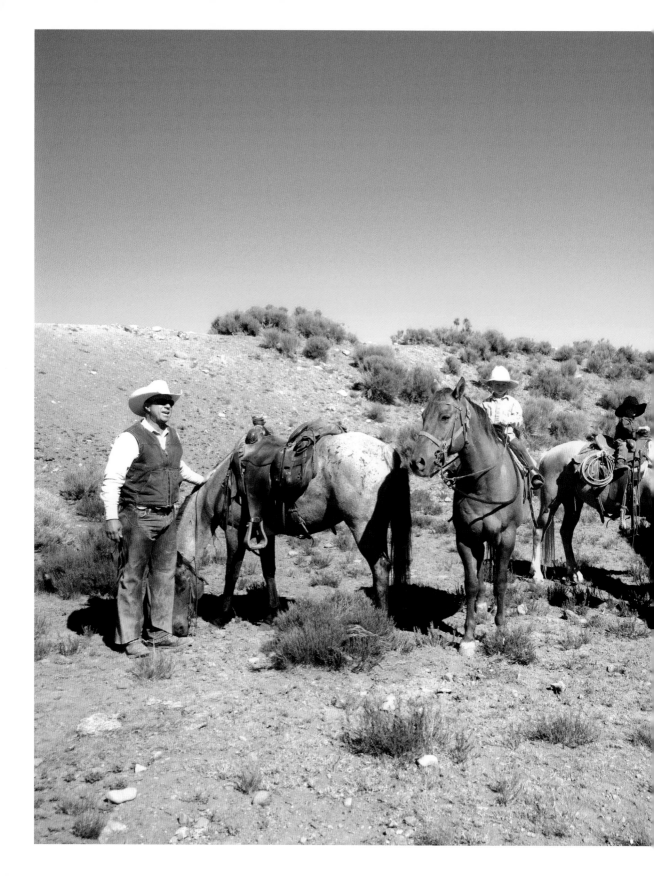

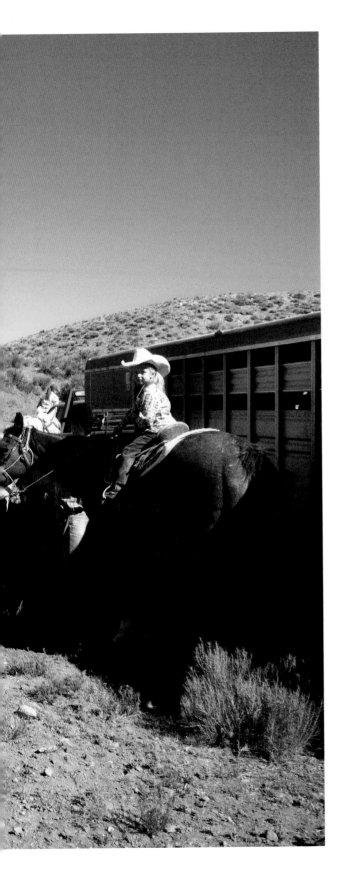

Antimony, Utah

"You guys workin' or playin'?" I asked.

"Well, we love the work we do, so there's not much difference between work and play," one gal replied.

They were in a rush to saddle up and wrangle 280 head of cattle to higher pastures before nightfall.

"You're not worried of falling off those things?" I asked the young girl who wasn't older than four. "We get them started young here," the patriarch moved in. "In hopes that they'll ride till they're old."

To signal that the conversation was over and they really did have to get going, he came over and handed me a five-dollar bill. "When you get to Antimony, buy yourself a burger."

"Wow," I said sardonically. "They've got five-dollar burgers there?" I asked, putting the bill in my jogger.

He mounted and rode off.

(Ten-dollar burgers at Antimony Merc.)

DAY 130 ◆ MILE 3,215

Stagecoach, Nevada

To start his day off, Coffee John watched a superhero movie in front of the Stagecoach Market.

"There's lots of Johns so they call me Coffee John."

"But that's an Arizona Iced Tea."

"Would you like me to go get a cup of coffee? For your picture?"

DAY 125 ◆ MILE 3,017

Eureka, Nevada

"Everybody here is Basque, Irish, or Mexican," a woman at the bar told me. "I'm Castilian. Not easy growing up here being Castilian."

(This was shortly after the Fourth of July beer drinking contest. Having taken the day off from running, my beer thirst was a little off and I did not win, but I did have the honor of meeting the 1996 Champion.)

Stagecoach, Nevada

"You wanna smoke a bowl?" He asked another guy on the shaded sidewalk, but the invitation was clearly open to everybody.

"I'm just digging holes today," he said. "Why not."

It was eight in the morning and the bald fellow with the dog passed around the pipe, all the while proclaiming how great it was that Nevada legalized marijuana. He then went into a story about driving up to Alaska with his family. On the return journey, crossing back into Canada, the border patrol found guns in his truck. They turned him around and banned him from entering Canada. He returned to Alaska to frame houses for a couple of months to make enough money to get his family, his car, and himself on a ferry back down to Bellingham. He noticed I was itching to get going so wound up his story. As he turned to get in his car, he abruptly changed the tone and topic of the conversation.

"Do you accept the Lord Jesus Christ as your personal savior?"

I was caught off guard and replied with as truthful a statement as I could muster. "Um, yeah, sometimes."

"Well, sometimes is better than never."

He got in his pickup where his dog was waiting for him. As he drove away, he yelled out his window, "Love everybody!"

Beneath Highway 50, Nevada

"Methane, ethane, propane, butane."

"2-propylheptane?"

"Well, with this bond . . . blah, blah . . .
2-methyl-4-propylheptane . . ."

In our culvert sanctuary, it just so
happened that there was both a student
and teacher of organic chemistry.

Yes, Brooks brought his chemistry
homework.

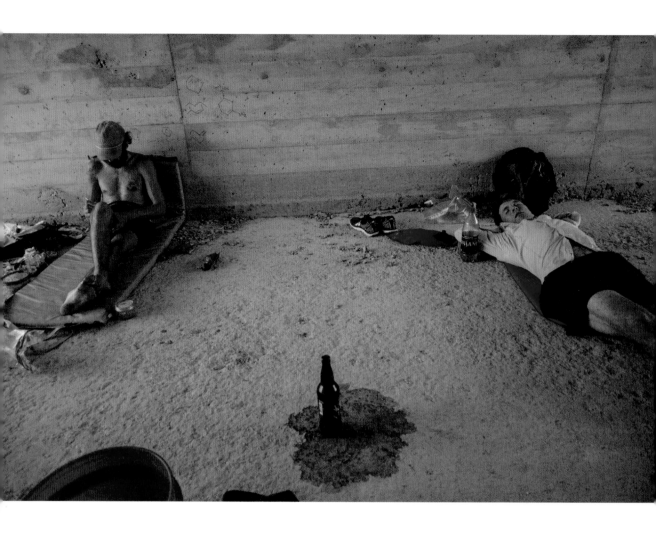

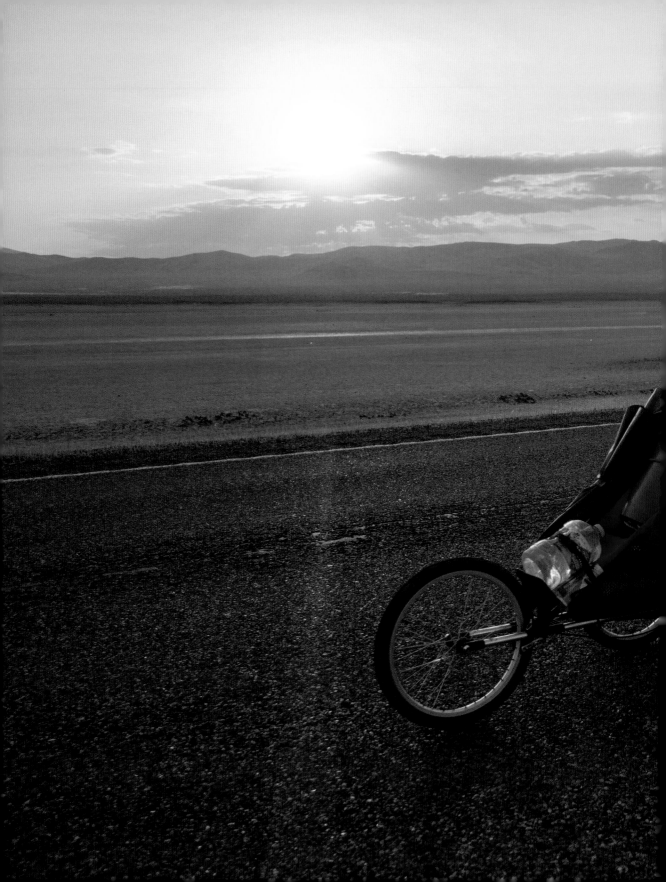

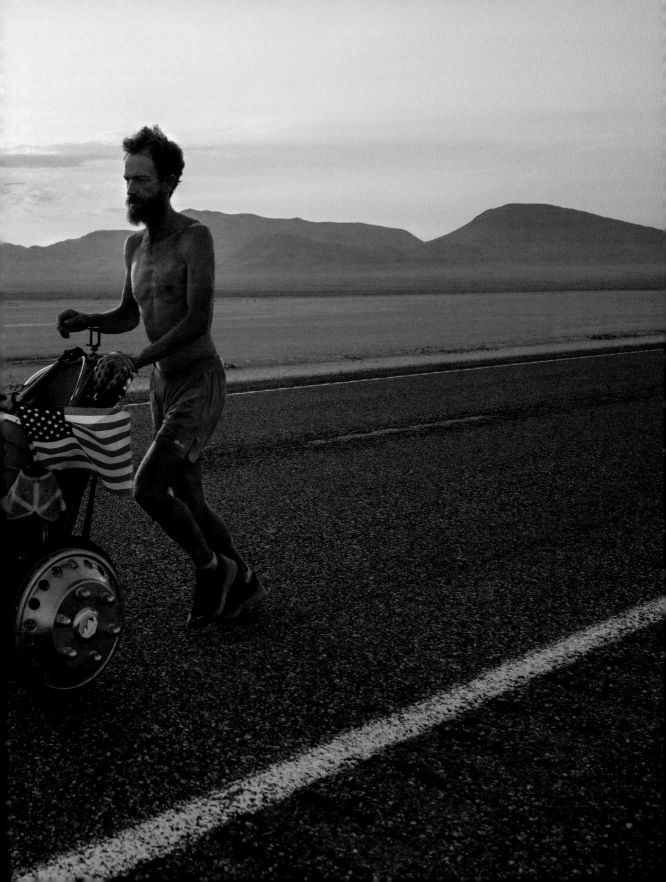

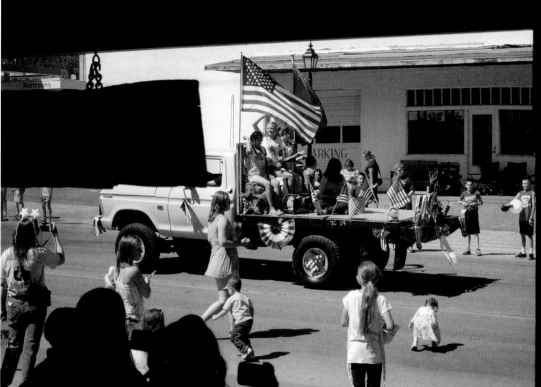

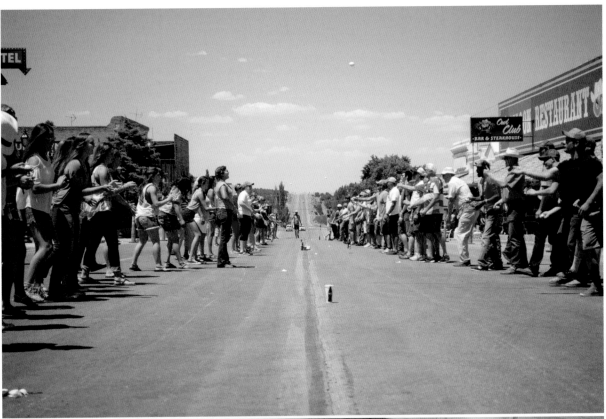

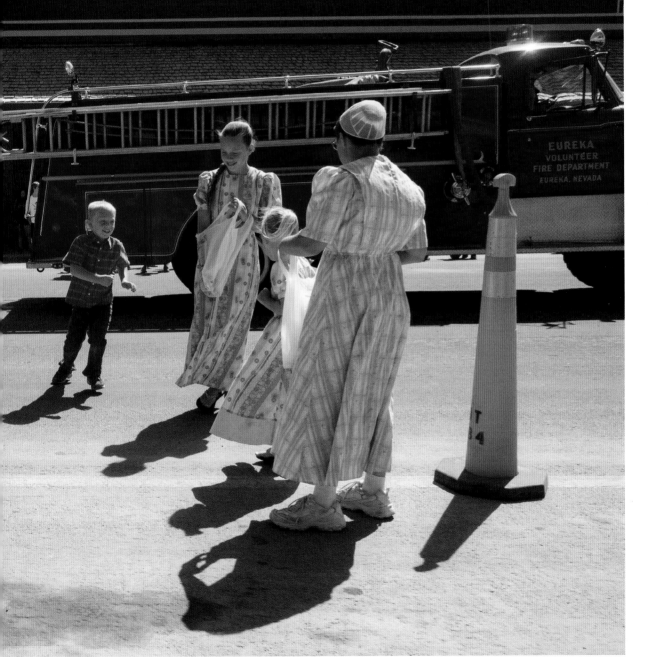

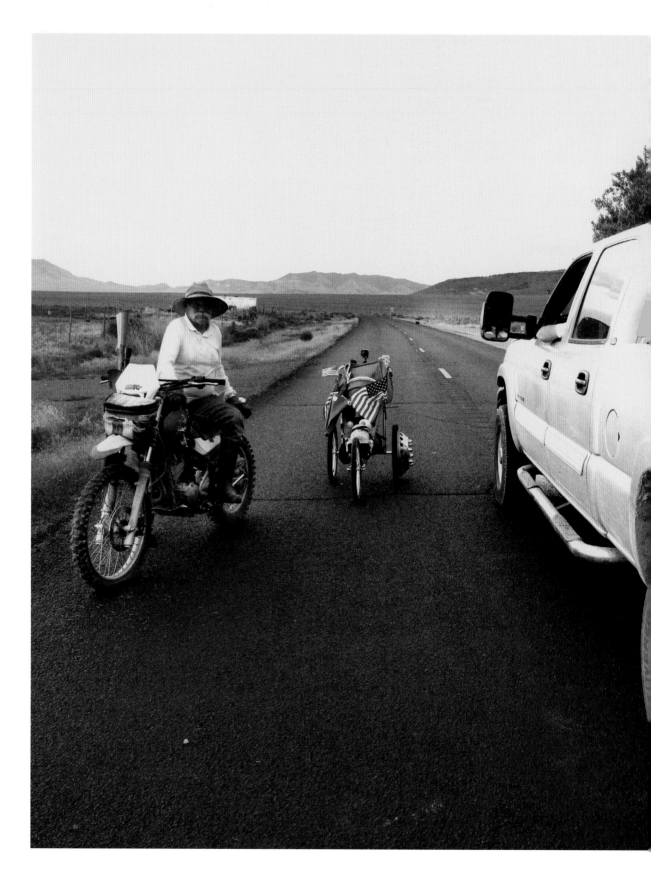

Middlegate, Nevada

"This seems like fine living out here,"
I said.

"I guess, if you don't know any better,"
said Shorty. He's on the bike. He was
born here on this farm sixty-four years
ago. His dad homesteaded this place in
the twenties. He was back at the
farmhouse, ninety-three years old,
tending to the garden. Shorty
explained to me about irrigating
(3-mile-long pipe coming down from a
nearby spring), the backup well (150
feet deep), where he grazes the cattle,
and warned me of the storm coming in.

"You got enough water?" he asked.

"Plenty of water, and a warm beer
for when I'm done for the night," I said.

At that, his buddy in the pickup
hopped out and handed me two
bottles of frozen water from a cooler in
the bed of the pickup. "Make it a cold
beer." I sandwiched my beer between
the two bottles of frozen water and
carried on.

THE
WEST
COAST

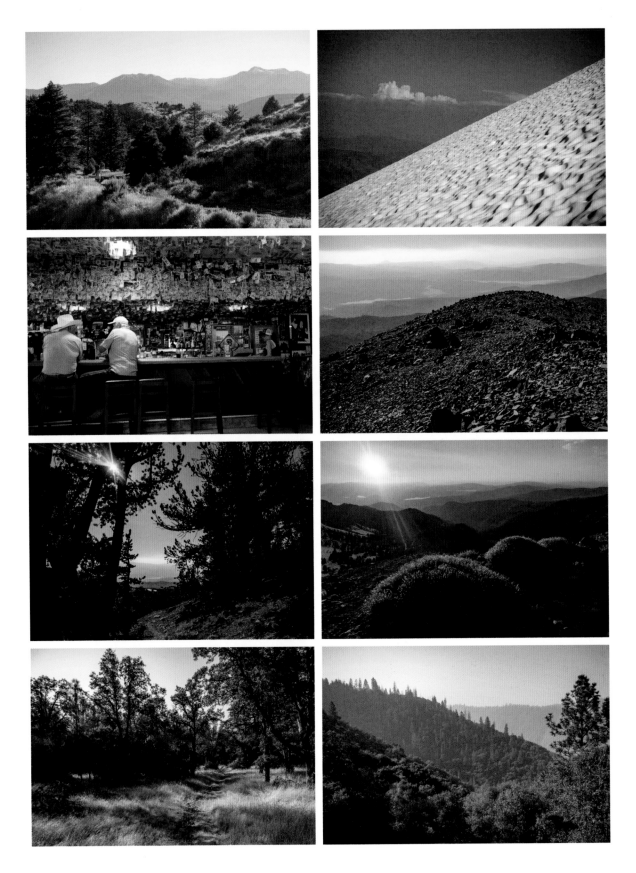

I had spent the night alongside a small lake just off a busy two-lane commuter road with rapidly moving traffic and no shoulder to speak of. Though it was quiet next to the road through the night, the buzz of the early morning commuters awoke me from my slumber in the predawn hours.

I had been in California for a little over a week, making my way slowly, now, toward the coast.

The Tahoe Rim Trail had carried me around the north shore of Lake Tahoe and to the start of the legendary Western States Trail, home to one of the most prestigious one-hundred-mile races in the world. In my desert haze, I had considered attempting a nonstop run on the course with hopes of completing it in under thirty hours—the official time cutoff for the race. But the fatigue hit me hard as I climbed out of the Great Basin to the apex of the Sierra Nevadas, and sitting and lying down were beginning to take on the feeling of actual pleasure, and I was craving it at the end of every day. Furthermore, these would be the last of the mountains, and to rush through them, I decided, would have been sacrilege.

As I approached the camp where I had hoped to stay on the first night on the trail, a mother bear charged me, protecting her two cubs high up in the trees. I didn't even have the energy to panic. I paused and made my way around to the right. She charged me that direction as well. I then tried moving around the three of them to the left, at which point the bear allowed me passage.

The following morning I continued my descent down into the Central Valley.

"There is science, logic, reason; there is thought verified by experience," Edward Abbey wrote. "And then there is California." It is really too much to take in. It is Steinbeck and Hollywood and the Central Valley and big trees and impenetrable mountains. It is the state that elected Arnold Schwarzenegger governor and nourished Apple and Twitter and Facebook and Google. It is the most populated state by 10 million people. By some accounts, California has the fifth-largest economy in the world. It is simply too much to absorb even at a slow jog.

I stood outside a bakery in Saint Helena that boasted English muffins that Oprah Winfrey had personally approved and wondered if I really wanted to spend five dollars because of that endorsement. An older man sitting with two older women sat eating fifteen dollars' worth of English muffins and fifty dollars' worth of mimosas. The two women were buried in their phones while the man sat looking at me.

I looked at my reflection in the bakery's window and saw a threadbare human wearing threadbare clothes. My unkempt beard, skin darkened by dirt and dust and sun. My pack, my hat, the creases around my eyes, all suggested an emptiness, a lack of tolerance. I, too, was staring at me.

"You're staring at me," I said to the older man. "It's rude to stare," I informed him.

You don't realize that a change is occurring within you. You don't realize that your patience has run thin. You don't realize that you no longer have tolerance for this type of person.

The man put down his mimosa while the two women remained focused on their phones. "What are you doing?" he finally asked. I explained that I was running across the country. And that, in fact, I only had a few days left to go.

Seemingly unimpressed, the man remained quiet but continued to stare.

"What was your favorite state?" asked the woman with her back to me, not budging from her phone.

"I'm sorry?" I said, insisting to myself and nobody else that she look at me while she talked to me.

"What was your favorite state?" she asked again, still entirely committed to her phone.

"I'm sorry?" I said again.

"I said," she said, and turned and met my tired eyes with obvious annoyance, "What was your favorite state?"

"Oh, there you are." The truth was, I didn't have a favorite state. Nor did I have a least favorite state. But curious what response I'd get from this audience I said quite simply that Arkansas had been my favorite.

"Arkansas?" the man said with surprise and disappointment. "All I can think about Arkansas is Trump and pigs." I asked if any of them had ever been to Arkansas and they all seemed quite pleased that they had not. I suggested they pay it a visit. "They're the most generous people I met on my run. And they look you in the eye when they talk to you." None of this was going very well. I was in a bad mood and knew that a five-dollar English muffin would likely make it worse, not better, so I opted to carry on.

One can anticipate a lot of things that a crossing of this magnitude can do. That it will allow an appreciation of food and water. That it will allow an understanding of one's compatriots a bit better. It can almost be guaranteed that true fatigue, true hunger, true sadness, happiness, and loneliness will be felt deeper than ever before.

What can't be anticipated, though, is picking fights with a trio of well-off, liberal septuagenarians.

I felt empty. Or almost empty. There remained a quiet rage that forced me to wonder what I had done wrong. I thought briefly about Jesus Christ's forty days in the desert whence he emerged tested and pure. Was that my problem? That I only spent thirty-one days out there? Did I need another nine days in the desert?

I continued on to the headlands north of San Francisco. Dairy cows dotted the fog-blanketed hills that were covered in tall grass and eucalyptus. Various cousins of cypress trees lined the roads and nestled into the hollows between the rises. On a hill above Tomales Bay I slept alone for the final time on this journey. The next several days would be a sea of people coming to celebrate my final miles with me.

Down the coast of Marin and over the Golden Gate Bridge, friends and family joined me. They thought I had something to say. I, too, thought I had something to say, but deep down I really just wanted to sit, be quiet, and enjoy the bird songs and crashing waves.

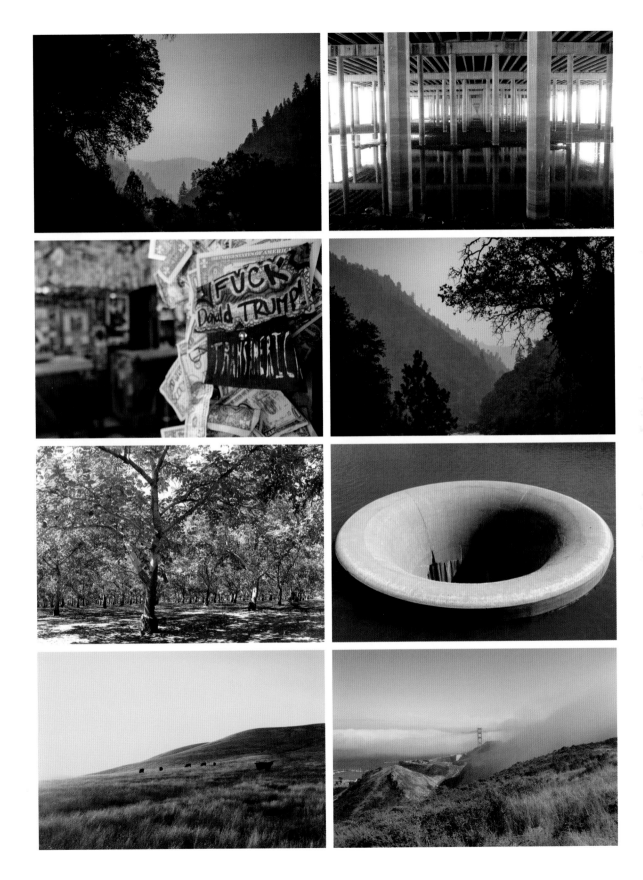

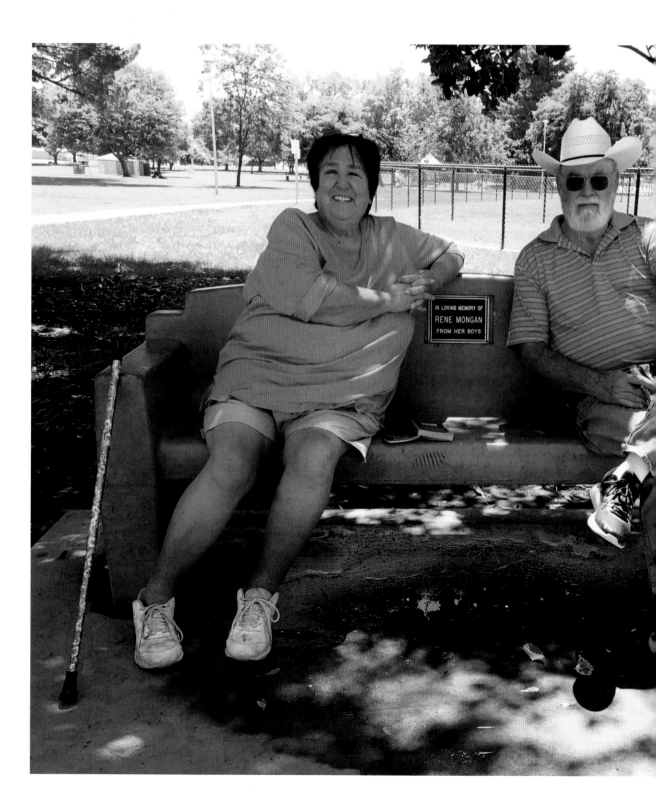

Sacramento, California

"Hey!" Sheryl called. "What are those, walking sticks?"

Anna Frost and I walked over to her and Earl, who was holding a mostly smoked cigar in one hand and a new one ready to go in the other.

"What year did you graduate high school?" she asked Anna as a way to find out her age. "Well you have the body of an eighteen-year-old," she said again and again.

Sheryl explained how she and Earl were best friends for forty years before they got married, to which he replied with a grunt.

"Honey, let's do a photo."

"Are you kidding me?" he said, using his words. He grunted some more and juggled the two cigars about but finally agreed.

Sacramento, California

"You know 'Got My Mind Set On You' by
George Harrison?'" I had to ask. It was
in my head for four hundred miles
across the desert. It's gonna take time,
a whole lot of precious time. It's gonna
take patience and time. The lyrics in
my head were of a few weak threads
keeping me connected to sanity. Anna
and I had been singing it throughout
the day and I thought hearing it might
help me release it.

Day didn't know it. He said it was
much too modern for him, but did
break out some earlier Beatles. After
which he explained that he's been a
professional musician for the past ten
years. "My wife complains that all I do
is ride my bike and play music."

"Sounds pretty nice to me," I said.

He agreed and then excused
himself as he peddled off on his
recumbent. "I got a gig later."

DAY 137 ◆ MILE 3,371

Robinson Flat, California

The Ghelfi brothers met me in the
morning to carry my pack and offer
me some company. As contenders in
most running races, they are more
accustomed to chasing down the
podium rather than plodding along at
my snail-like trans-America pace.

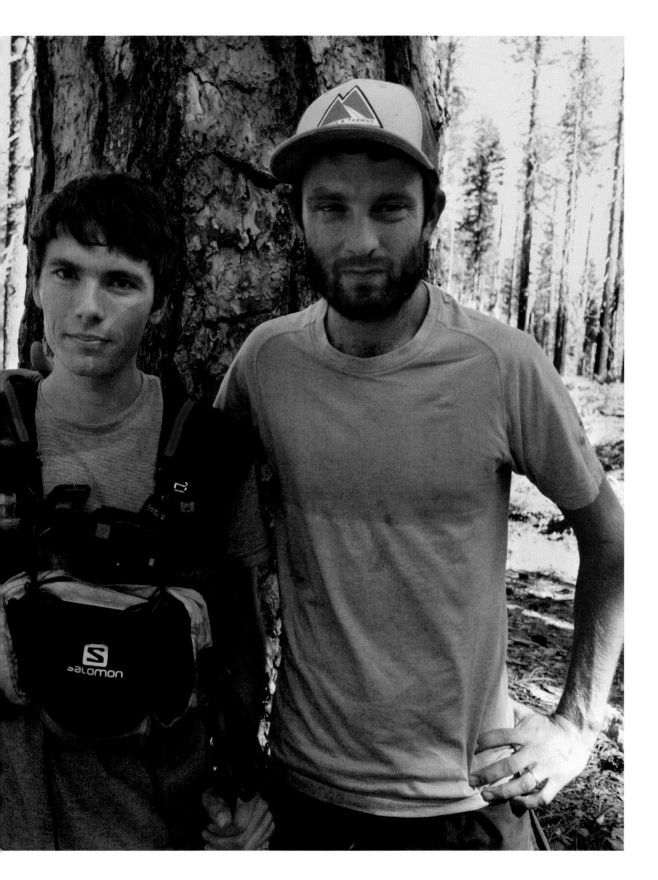

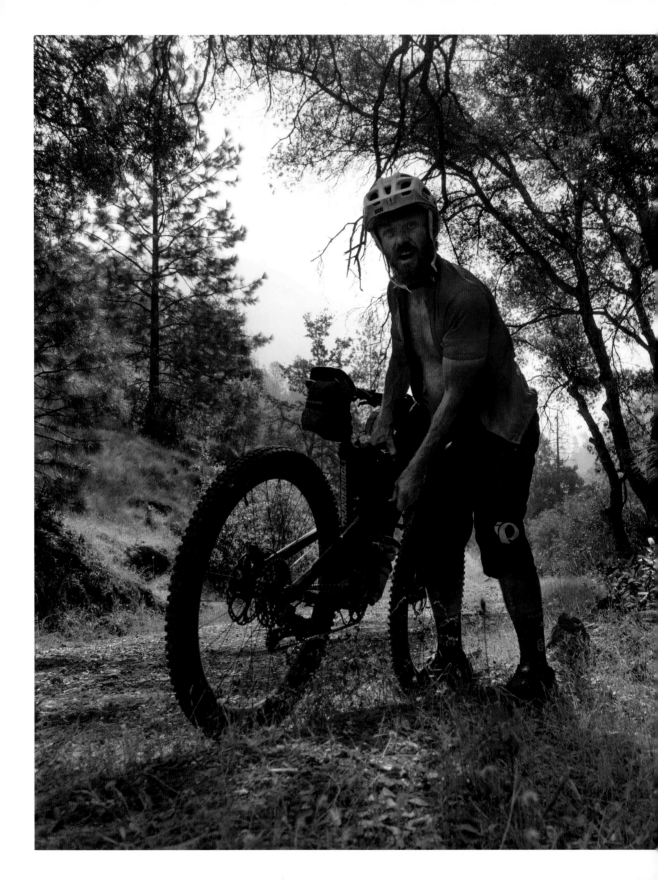

DAY 138 ◆ MILE 3,432

Foresthill, California

The bike packer was hauling but came to a halt when he saw me and I saw him. It was obvious to both of us that we were deep into our endeavors. He pulled out some fresh juice and packed a bowl to smoke. The bike packer was 250 miles into a 300-mile self-supported bike pack race.

"How you doing?"

He informed me that he was in first place. Thirty miles ahead of the next contestant.

"You crossing the river up ahead?" I asked.

"There's a river up ahead?" he replied. "I don't know, I'm just following the GPS."

I suggested we cruise together for a little bit.

"Naw, man. I get high and fly." And at that he took off.

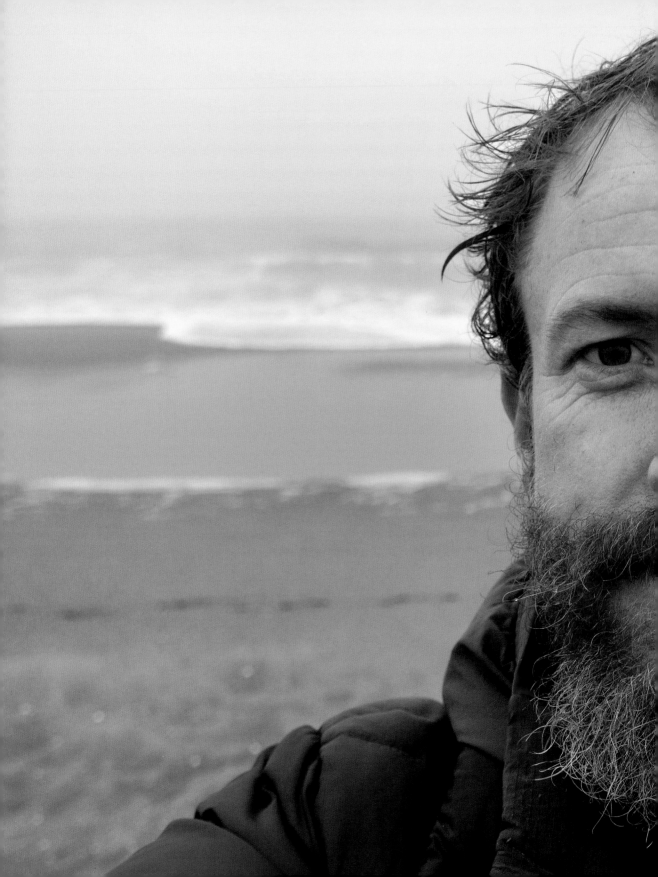

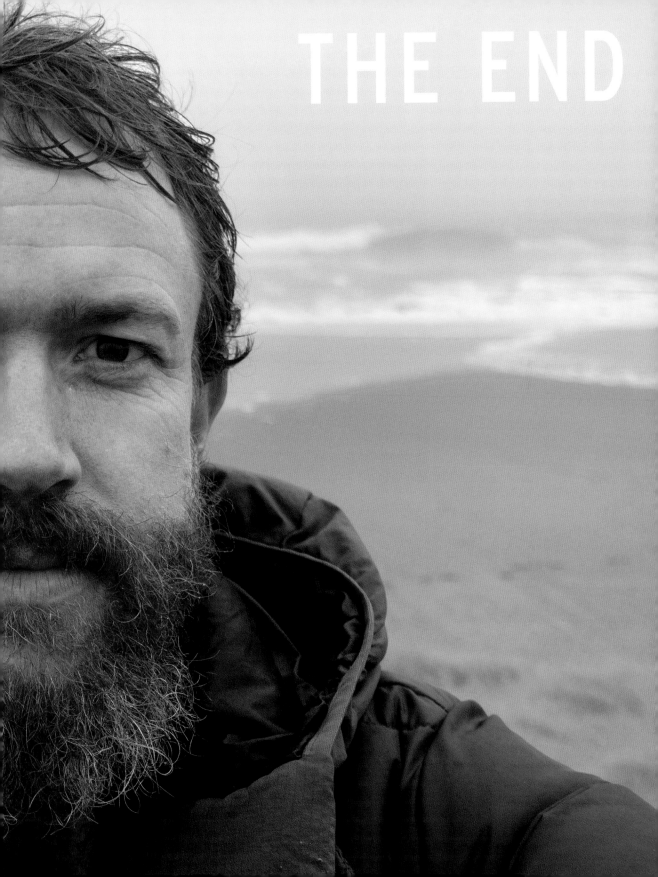

THE END

IT IS AUGUST 1ST, 2017. The sun is approaching the Pacific horizon as I submerge myself and take in the ocean's cathartic murmur. The water is too cold to be in there for long, but I am numb, both mentally and physically, so I hold onto the moment for a few seconds longer. Above the surface, on the beach, only a few feet away, is a collection of friends and family who have gathered at the western edge of San Francisco to help me finish a thirty-seven-hundred-mile overland journey across the United States.

The transition from the life I have been living for the past five months to the more sedentary one I'll be resuming tomorrow calls for this dip in the ocean. A baptism of sorts, to mark an abrupt transition of movement, function, and meaning.

On the far shore,
you're washed.
Twice baptized

A WEEK LATER I've spent most of my time sitting, or if not sitting, moving very slowly. From a patio in the Berkeley Hills, I scan the horizon, south to north, trying to take in the immensity of the population below me. Thousands of vehicles traverse the Bay Bridge, big jet planes come and go from SFO and OAK. A large cargo ship passes beneath the Golden Gate Bridge.

To cross the country on foot is, by definition, extraordinary. But, I'm realizing, that doesn't make me extraordinary. The City is a good vessel to show you that you are not extraordinary. The City does not care that you slept in a bathroom to avoid a storm or that you ran out of water in the desert and peed blood for days. The City just is.

The depths of my muscles and joints still ache immensely. I am happy to not be running. To be cooking for myself and washing my own dishes and sleeping in the same spot—these are some of the things that I had missed while on the road and I am now making up for it.

I am left with a new sense of wonderment as to how a population operates. I set out to cross America by foot to get to know my country, my neighbors, and our mutual history. Traveling along the Trail of Tears, the Pony Express Trail, the Santa Fe Trail is to know the pace of life in 1820, 1830, and 1860. Having traversed some of our most beautiful trails and natural landscapes, I began to understand the attachment we have to our land. After running across America, I thought I had a pretty good idea about what America was all about. And then I was given this brief and wonderful opportunity to sit above the San Francisco Bay and contemplate the human hive below and know that I know nothing.

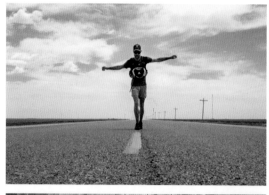
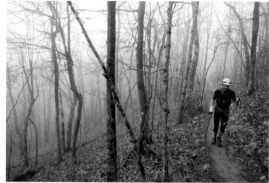

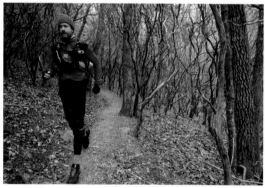

255

ACKNOWLEDGMENTS

In no particular order, I would like to thank John for shoes and Cheeba Chews, Brooksie for the baby jogger, *Trail Runner Magazine* for helping me through and publishing "The End," and *The Red Bulletin* for doing the same with "The Desert." I would like to thank my mom, dad, Fred, and Randy; Kate Woodrow and Richard Betts for believing in this book; Charles Beiler for the train ride; Mali and Jordan for the cookies and gummies; my support siblings Jim Steele, Liz, Jared, Dean, Salomon, and Kathy; and everybody that smiled at me, waved at me, ran with me, and prayed for me. We do these things for each other.

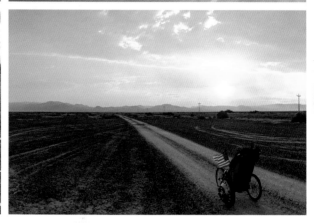